Unbroken Line:
Writing in the Lineage of Poetry

Author's List of Publications

Selected Poetry Books
The Widow's Coat, Ahshata Press, Boise State University, 1999
The Art of Love: New and Selected Poems, La Alameda Press, 1994
Pocahontas Discovers America, Adastra Press, 1993
True Body, Parallax Press, 1991
Acequia Madre:Through the Mother Ditch, Adastra Press, 1988
Aegean Doorway, Zephyr Press, 1984

Fiction and Autobiography
Dirty Laundry: 100 Days of Zen, La Alameda Press, 1997; New
 World Library, 1999 (with Robert Winson)
Coastal Lives, Center Press, 1991

Editor
*Across the Windharp: Collected and New Haiku of Elizabeth
 Searle Lamb*, La Alameda Press, 1999
Another Desert: Jewish Poetry of New Mexico, Sherman
 Asher Publishing, 1998 (with Joan Logghe)
*New Mexico Poetry Renaissance: 41 Poets, a Community on
 Paper*, Red Crane Books, 1994 (with Sharon Niederman)
The Buddhist Poems of Philip Whalen, Parallax Press, 1996
 (with Robert Winson)

Juvenile Nonfiction
The Mysterious Death of Malcolm X, Lucent Books, 1996
A History of Women's Sufferage in the United States, Lucent Books,
 1995
Tracing Our Jewish Roots, John Muir Publications, 1993

Unbroken Line:
Writing in the Lineage of Poetry

Miriam Sagan

Ackowledgements
I would like to thank Nancy Fay for the perfect title; Carol Moldaw for her kind and precise edit; Judith Sherman Asher and Nancy Fay for all their editorial care. Some of the section on "The Image" appeared in a different form in *The Writer*.

First Edition
ISBN 1-890932-08-6

Cover by Janice St. Marie
Cover Art by Roshan Houshmand
Interior design by Judith Rafaela

Library of Congress Cataloging-in-Publication Data
Sagan, Miriam, 1954-
 Unbroken line : writing in the lineage of poetry / Miriam Sagan.
 p. cm.
 Includes bibliographical references (p.) and index.
 ISBN 1-890932-08-6
 1. Poetry —Authorship. I. Title.
PN1059.A9S34 1999
808. 1 —dc21 99-21433
 CIP

Sherman Asher Publishing, PO Box 2853, Santa Fe, NM 87504
Changing the World One Book at a Time™

To my teachers and students

Contents

CHAPTER 1: INTRODUCTIONS

Your mother probably did not want you to be a poet. No doubt your mother wanted you to make something of your-self, get an education, make money, even be happy. But a poet, no. That is in part because the image of a poet in popular imagination is neither rich nor happy. We have two extreme views of the archetype "poet" in American society. One is of the self-destructive romantic, at best living in a cold water walk-up and dying slowly of tuberculosis, at worst populating the back ward of a mad house and eventually committing suicide. The other extreme is of the Famous Poet, which is really only a version of the first—a feted honored person of letters who, yes, usually ends up prematurely dead or insane.

There are other, more realistic, images of poets. Indeed, poets have been rebels, outsiders looking in at society, what Shelley hopefully called "the unacknowledged legislators of the world." Poets have also been integrated into society, whether as bards who were called upon to recite the feats of heroes, poet kings like the Biblical David, teachers of song and dance like the renowned classical Greek Sappho, the anonymous composers of work and fishing songs as well as early Blues, a school headmistress like Nobel Prize winner Gabriela Mistral, a doctor like William Carlos Williams, or an insurance agent like Wallace Stevens. Poets indeed go crazy, get drunk, act out, act up, and die by their own hand—but so do waitresses and bankers.

Still, as an aspiring poet, you may be handicapped by what society—and even by what you yourself—think of as the marginal role of the poet. As a very young woman I found myself at a cocktail party in snobbish Southport, Connecticut

with my boyfriend. A greying gentleman asked me what I did. Emboldened by alienation I announced: "I am a poet!" "I wrote a poem once," he said, putting me firmly in my place. I have found it, in the ensuing decades, much more difficult to declare myself a poet. A teacher, yes, or an editor, a freelance writer, even a mother—but declaring oneself a poet doesn't usually bring a useful reaction. What has helped me most in my quest for the identity of a poet is the sensation that I am not alone. Half unconsciously I began to harken back to the root of poetry—its ancient forms and traditions—for a kind of trustworthy company. I also sought community and peers among the living, a support fraught with more vagary, but support nonetheless.

I wrote this book out of what I learned from thirty years of taking poetry seriously. This is the book I wish I had been able to read when I first started out writing poetry as a teen-ager and as I continued along a path that often felt very lonely. Yet despite the lack of support, the urge to write persists for many of us, even overwhelms us with its necessity. For such a person, this book attempts to present the major formal aspects of poetry in an accessible manner. Poetry, of all the written forms, has the most rules; for example, a sonnet or even a haiku has far more agreed-upon formal rules than the much weightier novel. Rather than discarding these forms or being intimidated by them, the contemporary poet can embark on them as an ancient path. Poetry is a lineage art, with deep roots that still work for us today. Much of this path is learning to concentrate on the mind of poetry. Usually our state of mind is focused on the practical—laundry or taxes—or on the wishful—winning the lottery or true love—or on the fearful—cancer and worry. By learning to focus your mind on poetry, you will allow that to fertilize your

imagination, and you might be honestly able to say to a banker at a cocktail party: "I am a poet!"

This book includes a look at and complete how-to on some of the most fabulous, and productive, poetic forms, from the pantoum to the villanelle. It also addresses issues most books on prosody do not consider—such as how it is possible to become a poet in our society, which doesn't really support the endeavor, and by extension how to live as a poet, even as a person with work and a family, rather than in a cold-water flat.

I carry some negative images of my own about poets. I can still see the dramatic genius reading to an overflow crowd in a haze of needy narcissism months before her suicide, and more than one well-established personage almost too drunk to follow his own words on the page. But I also have more serene images: a Persian miniature of a bearded poet in his illuminated garden, a Japanese screen painted with a black haired writer bent over her brush. And among my friends I see poets stirring stew and caring for babies, running bookstores, going to jobs and coming home—and remaining poets.

Much of the process of writing described here was test-driven in my poetry classes at Santa Fe Community College. Like so many community colleges today, SFCC is an unsung treasure, serving a broad spectrum of students. Sometimes I would look out over my class and feel panic start to rise. They were such a disparate group: accelerating high school students, retirees, working adults, punks with pierced tongues, world travellers, those who never left the county, people whose first language was Spanish, Italian, or Tewa, gay, straight, young, old, hip, provincial—and they were all

looking at me expectantly. Luckily, it was not just me they were looking at, it was also the tradition of lyric poetry, with its mix of individualism and tradition, something we could all enter and follow together.

CHAPTER 2: APPRENTICESHIP

Entering the Lineage

Poetry is a lineage art. This is one of its most important elements, but one that is largely ignored by the contemporary aspiring poet. A lineage art is one that is passed from generation to generation through a student/teacher relationship that emphasizes craft. The martial arts of Asia are still taught in this manner, even in a dojo in Brooklyn. A hundred years ago if someone in Vermont wanted to learn ironwork, the student went in search of a master to learn from. The same would be true of Navajo weaving or Japanese ceramics. Today, however, poets tend to think of themselves in a highly individualistic manner—after all, this is America, isn't it, and we can make ourselves up as we go along. I have found this individualism lonely, however, and when I first began writing it was a relief to admit, despite my adolescent egotism, that I certainly wasn't the first person on this earth to be a poet. And so I set out to learn.

Apprenticeship is certainly easier when you are young, but any time that you are young in craft is the time to learn—and to learn for at least a while without judgment or critical thinking. My early learning took place in a conventional setting—school. My first teacher was my sixth-grade English teacher—a tough cranky elderly woman from the Texas panhandle who had somehow found herself in New Jersey. Her name was Miss Penell, and she favored odd outfits of clashing greens and purples. She glared at me—an indifferent student at best—and decided to teach me two things: spelling and poetry. She failed to instill spelling into my brain, which was constantly befuddled by my then undiagnosed dyslexia. But the poetry caught me. By the age of twelve I could write

what passed for haiku in New Jersey in 1966, and win a contest with my rhyming quatrains. Miss Penell became my paradigm for a poetry teacher—strict, demanding, craft oriented.

Robert Fitzgerald, Harvard's famous classicist and translator of Homer, was just as strict as Miss Pennell, and no better dressed in his rumpled grey suits. He was my advisor and personal tutor at Harvard, which was my great good fortune though attributable to no particular merit of mine. Despite the Ivy League setting, I was as undistinguished a student as I had been in the sixth grade, completely failing to get into the creative writing major, which was known as the elite and coveted "Option Three." I arrived in Mr. Fitzgerald's dingy crowded office, sobbing. He was a reserved person who did not have much tolerance for hysterics. "I did not major in 'Option Three,'" he said dryly, "And it didn't do me any harm."

Cut It Out

It didn't do me any harm, either, because I had Robert Fitzgerald. I was going through a surrealistic poetry phase, and gave him one opus which was crammed with images, including the (I hoped) shocking ones of men masturbating in submarines, cages of parakeets and naked women, and people with the faces of animals. Mr. Fitzgerald sat quietly at his desk, his sharpened pencil poised at the top of my poem. He began to cross out, starting with my first line, and running deliberately—5-10-12-15—lines down, until he stopped. I held my breath. "The poem starts here," he said.

Of course he was usually right, but for an entire semester I'd sit in weekly agony as Mr. Fitzgerald crossed out my lines. Still, his coolness was a lesson to learn from. The technique

of starting is a difficult one. I now almost inevitably cross out the first few lines of any poem—they are my warm-up. When you write a poem, try throwing out the first ten lines. Were they perhaps a simple bridge to get into deeper material? Many poems will begin to heat up anywhere from two to twenty lines into the work. *Start there.* I have seen many student poems ruined because the poet had an unexamined attachment to the opening.

Another spot in a poem that can be weakened by material that simply doesn't belong there often occurs about two-thirds of the way down the poem. Check the second to last section—cut it ruthlessly if it seems weaker than the rest. Most importantly—*get used to throwing out lines you like.* The integrity of the poem is more important than the interest of individual lines. Cut lines that don't fit with the flow, throw in extraneous images, or are from some obsession that simply needs its own poem. If this process is too terrifying, *save* those cut lines—in a computer file, at the back of a note-book, and make other poems with them. But frankly I doubt if you will use them much. What Robert Fitzgerald taught me was a theory of abundance—we weren't living in a universe of poetic scarcity, where there were only a few lines to go around. So learn to throw things out.

In graduate school I had another wonderful, if intimidating, teacher, John Malcolm Brinnin. He was a large man with old fashioned manners who had written an important book on Dylan Thomas. But he did not give an impression of taking himself too seriously, and in Boston's wet winters would change from damp boots into a pair of fluffy pink bedroom slippers in his office. What I learned from Brinnin was more about the social role of the poet than technique. At twenty-three, I gave a reading at a local women's center and was

stunned to find my work attacked by the audience. At a distance of twenty years, it's hard to remember the details, just that the work wasn't political enough, or political in the right way, or had men in it, or too much nature, or the wrong kind of nature, or something. Reading in public was still new to me, and I was devastated. Still shaking, I went to Brinnin to ask for his help. "There is nothing wrong with these poems," he said, "and any poet who is worth anything has been attacked. Get used to it."

Robert Fitzgerald and John Malcolm Brinnin were both incredibly tough minded. They were old-fashioned, gentlemanly scholars—and couldn't have been more different than a Jewish girl from New Jersey. Still, they both taught me to tolerate fear, whether in the poem or in the world. These were lessons that didn't wear out, but gained in meaning for me as time passed.

Finding a Teacher

If you are an aspiring poet, should you look for a teacher? The answer is a qualified yes. There are certainly many poets who had no direct teachers—think of Emily Dickinson, for example. But poets do teach; the Greek poet Sappho had a school for singing, dancing, and poetry on the island of Lesbos, and Gabriela Mistral, the first Latin American woman to win the Nobel Prize, was not only the headmistress of a school but also the mentor of Pablo Neruda. Today teachers are to be found in schools—whether graduate programs or community college adult education. But don't necessarily expect any teacher of a poetry workshop to become your capital "T" teacher. And don't be afraid to explore—to learn technique from one person, revision from another, a positive attitude from a third. A poetry teacher is not a guru— nor should she or he expect or receive devotion. Be highly

cautious of any teacher who shows an inclination to misuse sex—or power. But if you can find a poet with something true to teach, stick around as long as you can to learn. I never questioned Robert Fitzgerald's editing pencil, because I had implicit trust in his judgment. When I started teaching poetry myself, the year after I graduated from college, I went back to visit him. I complained that before every class I felt terrified and sometimes stopped speaking in mid-sentence feeling as if my soul had astrally projected and was hanging from the ceiling. "It wouldn't be teaching," Fitzgerald said, "if you weren't afraid." And it wouldn't be learning either.

An Apprenticeship at Any Age

I decided I wanted to be a poet when I was sixteen years old. I did the most logical thing I could think of—I got a big notebook and decided to write a poem a day in it. You could do worse than to begin this way. My poems were terrible, of course, but it hardly mattered, I was too busy enjoying writing them. In my twenties, I became even more serious about my art. I took a romantic, and ascetic, approach. I had inherited what then seemed like a lordly sum from my grandfather, which parceled out carefully could support me. I moved to San Francisco, into a bare room in a communal house that was furnished with only a futon on the floor, a crystal casting rainbows in the window, and a shabby desk with my manual typewriter on it. Looking back at my account books of the time is both amusing and terrifying. I lived on six or eight hundred dollars a month, alternated dinners of Ramen noodles and scallions with boiled potatoes and cabbage, owned one purple skirt, and considered buying a paperback book a budget-breaking splurge. However, by the time I was thirty I had published a book of poetry; a few years later I could make a living writing and teaching. I had been a kind of nun for poetry—temporarily rejecting the things

of this world. It worked for me, and luckily I realized that this extreme state was an apprenticeship that would not go on forever. But it was a hothouse in which I developed—despite boredom, isolation, and doubt—as a poet.

But what if you aren't a fanatical twenty-five-year-old? What if you are twice that age, with two children, a mortgage, and a job? And what if you have decided you want to write poetry? How do you create an apprenticeship—an intense period of learning as a beginner—out of an ordinary busy life?

Anything that is developing needs shelter, whether a child in the womb, a new rose bush wrapped in burlap for the winter, or a poet in embryo. To create an apprenticeship you will need certain ingredients: time, space, and money, but these may vary according to your resources. Of these, time is both the simplest and the hardest. Everyone has time. Poetry is by its nature a short form—it is not the novel. But where is this time to come from? I am a firm believer in short, but frequent, writing periods. As an apprentice, try writing for thirty—or even ten—minutes a day. Remember, the greatest gap is between NOT writing and writing rather than between BAD writing and GOOD writing. As an apprentice, your major goal is to develop the habit of writing every day.

If you don't have ten or fifteen minutes in your daily schedule, *take it*. If a doctor told you you had to walk a treadmill fifteen minutes a day—or die prematurely from a heat condition—no doubt you would do it. Regard your short, but necessary, writing time, as a prescription on the level of life and death. With this time you can become a poet, without it you will simply remain a banker, a waitress, a parent, and whatever else takes up your time. Be prepared to sacrifice for this time—maybe it means you can't read

the newspaper or keep the house perfectly clean, maybe other people will be baffled or irritated by it. Your job is to not care. After all, I know a hundred ways to cook Ramen noodles, and it did me no harm.

Virginia Woolf said famously that to be a writer one needs an independent income and a room of one's own. This seemingly reasonable statement has haunted me. What if these resources just aren't available? I currently write in a hundred-square-foot studio my brother designed and built for me in my backyard. This is the perfect solitary writing space. But I have also written in other circumstances. When my daughter was born I moved her into the second bedroom, which had been my study. I put my desk in the bedroom. A dreadful arrangement—but I did not let it stop me. I once heard the poet and novelist Demetria Martinez say that the first book is written at the kitchen table; when a writer has more money and reputation, then the writer gets a studio.

You must learn to substitute your writing notebook, and the focus of mind it represents, for a cabin in the woods. Poets tend to be fetishistic about their notebooks—small, large, fancy, plain, lined, unlined—take your pick, and get to work. The covers of the writing notebook create your solitude and concentration. I once asked the poet Leroy Quintana for a creative statement to accompany some work of his I was anthologizing. He wrote me a chatty letter about his teaching responsibilities in San Diego, his teenagers, their cars—and all the automotive problems these vehicles represented. Then he added simply that he carried a small notebook in his pack or pocket wherever he went. This enabled him to write. Try to learn to keep notes and first drafts in longhand. Poetry was invented long before the word processor, and does not need one until the revision process, if then. I put

only my final draft on the typewriter or computer. Now take your notebook in search of solitude. When I was young, I loved to write at the Cafe Algiers in Cambridge. Drinking grenadine soda the color of rubies and eating exotic North African delicacies I felt far away from the mundane. Housesit over a weekend for a friend, or even arrange to use someone else's empty space for an hour now and then. You must become a snail—carry your room of your own on your back, and have it handy any time.

Money is a difficult issue for the aspiring poet to address, because we often think in all or nothing terms. I can't count how many times I've had aspiring writers come to me, hoping I'll advise them to quit their jobs. I look at these lawyers and business people and wonder why they want to quit, so I suggest they go down to three-quarters time so they can still support themselves. But this is unromantic advice few want to take. Your goal though is to start writing—and to be able to continue. Invest small amounts of money in yourself as you go—a day off work, tuition for a workshop. I know a librarian with a high-powered administrative job and a complicated family life. She began by simply investing two or three hundred dollars a year in her poetry—going on a short retreat, buying literary magazines, even on a roll of stamps to send her work out. Start small but stay serious; this is your garden and you need to water it.

A Life of Reading

You cannot become a poet if you do not enjoy reading poetry, and read it continuously. In general, no one can write what they do not read, whether murder mysteries or sonnets. Next to writing itself, reading is the only other necessity for a poet. When I first set out to be a poet, in my adolescent enthusiasm I set out to read *everything*. I didn't have the education to differentiate, so I figured I'd just read every-

thing great poets had written. I read the collected Keats, Shelley, Byron, Yeats, Thomas, Wordsworth, Whitman, and Frost. I read Dryden and Pope—whom I hated. I read all of Emily Dickinson. I didn't understand much of it, didn't retain all of it. I'd actually write the date next to complicated lines I thought I'd finally deciphered. I read all of Shakespeare except the Histories. I read on buses, when I should have been studying for exams, waiting on line. In the summer I liked to go to a nude beach that involved walking around a slippery mud cliff. I'd carry two or three library books on my head, wrapped in a towel. And I once had a lot of explaining to do when I slipped and fell into the water, soaking the collected Edna St. Vincent Millay in a salt wave.

As I was busy reading without direction I wasn't even that aware of contemporary poetry at first. As a teenager, my main access from the suburbs to the glowing metropolis of Manhattan was through the portals of the Port Authority bus station at 179th street. In those days there was an excellent bookstore in the station. They had a shelf of New Directions books, and I read Rexroth's translations from the Chinese and Federico García Lorca. By college I'd read all of Denise Levertov, Theodore Roethke, and Adrienne Rich. I went to two or three poetry readings a week; I spent hours in the library listening to recordings of poetry with headphones. This uncritical immersion was a basic education. It put cadences, rhymes, flow, taglines, and references in my ear.

Start reading. Read poetry every day. Read at least five poems a day as part of your writing routine. There are people who are afraid that they will substitute reading for writing— if this is the case, limit your reading time and don't count the reading of long Russian novels or suspense thrillers as

poetry time! There are aspiring poets who claim they don't want to be influenced by the work of others. But this is a necessary part of your apprenticeship. You must be influenced, and the greater the influence, the better your models—the more you will learn. Come from a position of modesty—the great poets do indeed have something to teach you. A poet can work without living teachers but not without dead ones.

The Path of Form

In the end, the best teachers you can find are the poetic forms and conventions themselves. I think of the path of poetry as being quite literally a path—sometimes difficult, sometimes easy. You can visualize any way that works for you, whether it is a path through a forest or the New York subway system. Don't imagine that you are making poetry up from scratch—this is much too difficult and much too egotistical.

In New Mexico there are many ruined cities left by the ancient Anasazi as well as by the historical pueblos. At Puye people lived in cliff dwellings and farmed the top of a mesa. Handholds and toeholds that are hundreds of years old still exist in the cliff. If you were to climb, you would do best to follow the path already there. On the island of Kauai in the Hawaiian chain, the Na Pali coast is an inaccessible cliff dropping down into the Pacific. Stones cut by the ancient Polynesian people still delineate the trail. Only a fool would go off by herself among jungle and mud when a trail, however minimal, already exists.

In order to immerse yourself in the traditions of lyric poetry, you must apprentice yourself to form. This may not fit in with the individualism of our society, but poetry, like all art

forms, transcends the individual. Pack as you would for a journey, but instead of freeze dried stew and water you need a notebook, a pen, and some books to read. Now your journey begins.

CHAPTER 3: WALKING THE LINE

I once asked a group of fourth graders in Albuquerque, New Mexico what the difference is between prose and poetry. Their answer was to the point: "poetry doesn't run all the way to the end of the page!" they shouted. The fourth graders were right, although the difference between prose and poetry is not so much typographic as breath oriented. The basic unit of poetry is the line, while that of prose is the sentence.

It is critical to note that the basic unit of poetry is not, as some aspiring poets mistake it to be, the word. Most poets are easily seduced by the beauty of individual words. I myself had a startling experience with this once. I came home to find a list of words in my husband's handwriting propped up on my typewriter: "silver," "moon," "azure." Tears came to my eyes, the words were so beautiful. "What is this? It's so beautiful!" I asked. He laughed. "I went through your poems and picked out words you always use. No wonder you think it's beautiful," he said.

But like seashells picked up on a tide line, which unpacked after vacation look dry and lifeless, individual words are not enough. The French writer Colette admonished: "Don't look for the rare word." Poets are not stamp collectors or netters of butterflies, looking for the perfect specimen.

The line of poetry can be as elusive as animal tracks or as perfect as a taut wire inviting the aerial artist to cross. No line in English can exist without the echo of dance and of the ancient measures of Greek and Latin, and even in free verse the poet should not be walking blindfolded above the circus.

Iambic Pentameter

Before poetry was written, it was sung and danced. It is no coincidence that our metrical or rhythmic unit is called a "foot"—in ancient Greece dancers' bare feet hit the dusty ground in concert with chanted words and the beating of a tambourine. In Greek and Latin meters for poetry are as strict and mathematical as scores for music. The same cannot be said, of course, for English. The touchstone for us, however, even in America at the end of the twentieth century, is iambic pentameter. Forget what your high school English teacher told you: iambic pentameter is rarely ten syllables with five stressed—or heavily accented—syllables. Read any sonnet of Shakespeare's and you will see that his lines run from eight or nine syllables to eleven or twelve. Sometimes they are ten, sometimes not.

Most students are driven mad by trying to deduce what syllables are "stressed" or not. You can try banging them out as you read, but it is possible no two readers will agree completely. Relax—iambic pentameter is approximate. And what is approximate closely imitates actual speech. There is a story about a Shakespearian actress who couldn't stop speaking in pentameter. "I asked for wa-ter boy, you brou-ght me beer," she chastised the busboy. Why does this sound so stilted? The problem is that contemporary Americans, unlike sixteenthth-century Englishmen, don't speak in a way that resembles iambic pentameter.

Twentieth-century American poets William Carlos Williams and Charles Olson tried to change the shape of metrics to imitate American speech. Olson's theories seem needlessly complicated when you read them—after all, this is about simplification—but the basic idea works well. He and Williams

suggested counting syllables, rather than stresses. You can easily write a poem this way, limiting the number of syllables per line to any number, such as seven or eleven, or you can vary where you need to, starting off with a set grid, running free, then returning to the base line pattern.

Count It

Take off your shoes and socks. Look at your feet. Are they large? Small? Dirty? Cracked? Smooth? Are you a distance runner, a lounger, a stroller, a sprinter?

Poetic lines come out of the experience of the body. Learn to count. Use your fingers—there is no elementary school math teacher to criticize you here. Take a poem you are working on and standardize all the lines in terms of syllabic count. As you count syllables you'll notice that not all syllables are created equal—some are long and spacious, some very short. But count them the same. Read the poem aloud. Now vary the lines—break each line when you run out of breath and need to inhale. Which works best for you? Try to use a combination of the techniques.

Tip: when you are starting off, use longer lines of at least eight syllables. Very short lines can have the anorexia of fashion models, particularly when you are still developing technique. Push the line out for a more organic sound.

Breathing in the Air

Another way to investigate the poetic line is to see it as intimately tied to breath. One of the mystical qualities of poetry is that it influenced by breathing. For human beings, breath itself is a fascinating process. It is one of the few functions in the human body that is simultaneously voluntary (you can hold your breath, for example) and involuntary (you breathe even when asleep). You would have to be

an advanced yogic practitioner to alter your heart rate or blood pressure at will, but anyone can alter breath, which is why children love to see how long they can hold it!

The word inspiration also has two meanings. One of course is to become excited or motivated about something. The other means to draw breath into the body. Right now, notice your breathing. Is it shallow? Deep? Even? Now stand up. Does anything change? Take a deep breath; draw as much oxygen as you can into your lungs. Think of this as a concrete form of inspiration, one you can practice any time you want to start writing. The type of breathing we do influences who we are. Soldiers often have a shallow type of chest breathing as they stand at attention, which is why they can faint on parade. Shallow breathing isn't an authoritative stance, and may make you more liable to follow the commands of others. Zen meditation encourages abdominal breathing, which is very grounded but which also doesn't use the full range of human breath. The yoga tradition encourages a three-part breath, which allows you to experience the lungs as filling in three parts from the bottom up, then emptying on the exhalation. Notice too that you do not breathe just "with" the chest. The muscles of the back also must move for you to breathe.

I became particularly conscious of breath when I almost died of a lung ailment. I was twenty-one years old when my lungs collapsed and filled with fluid as a deadly side effect of the common flu. I spent weeks in the hospital wearing an oxygen mask, painfully aware of what my breath could and could not do. One of the first things I did on returning to the ward from the Intensive Care Unit was to scribble a poem in pencil on a crumpled piece of paper. It was about breath, full of images of balloons. My roommate, a chic woman who had simply had her gallbladder out, was curious about my scribbling, but I was much too shy to announce myself a

poet. Still, I had to get it down—I had discovered how critical my breath was.

Because the breath stops and starts, it is an organic measure by which you can break a line of poetry. One simple way to construct your lines is to break the line where you would pause to breathe. To find out where this is, read any poem of yours aloud and score it with a mark when you inhale. Then rearrange the poem so that you are inhaling at the start of each line. You will probably find your lines also run syllabically from six or eight to ten syllables, naturally following meter. Breaks occur several places in a poem. There are the breaks at the end of lines and there is also the ceasura, which is a break in the middle of each line. The ceasura is not very important in contemporary American poetry, but it was critical in Anglo-Saxon narrative poetry and in the ancient Hebrew. If you find that a line feels flaccid or weak, check and see if the two halves on either side of the ceasura are well-balanced.

Stanza

Another place where breaks occur in poetry is in the arrangement of stanzas, groups of lines set off from other groups by white space. Some poems have no stanza breaks at all, and while one line stanzas can occur in a poem the true stanza tends to run from two to six lines. Each kind of stanza has its own feeling tone, based in part on the almost mystical sense of its number. Stanzas, like metrical feet, are a remnant of a time when poetry was written for music.

Two-line stanzas are called couplets. Two liners, like two people, tend to feel compact and complete. Double this and you have the four-line quatrain, basis for ballad meter and many other forms. The quatrain is a four-legged table—stable

and balanced. Three-line stanzas are fascinating—stable too, like a tripod, they have a bit of excitement that quatrains lack. These triplets seem to want to spill quickly into the next stanza, often giving a sense of motion. Longer stanzas are really composed more of their component parts—five-line quintets break down into a triplet and couplet; six-line sextets can be a quatrain and couplet or two triplets.

When you first start off writing stanzas you will usually be following a set form. But the most important thing about stanzas is to be aware of them. Formal stanzas change the musical quality, and sense, of a poem. Try taking a poem you have written in free verse and break it into a variety of stanzaic forms, from couplets to sextets. See what each possibility does to the poem. Then break the stanzas freely, as kind of verse paragraphs that just break whenever the sense changes. See what you like best.

"Stanza" means "room" in Italian. The poem has an architectural quality as well as a musical one. Controlling the breaks in a poem helps give the poem a more three dimensional feeling. These breaks, often dictated by breath, include line breaks, ceasuras, and stanzas. My teacher, John Malcolm Brinnin, divided the arts into two categories: time arts and space arts. Poetry is a time art, for like dance and music its movement is temporal. Sculpture would be the quintessential space art. Metrics make the poem move in time. Still, every poem also seems to have a longing to take up space. Its arrangement on the page, those black words against white space, whether in a wild typographical array or a traditional stanza arrangement, makes the poem more concrete.

CHAPTER 4: SOUND AND METAPHOR

What Is Lyric Poetry?

There is more than one kind of poetry. The basic division in the ancient world was between the lyric poem and the epic poem. The epic told tales of war and conquest, the history of a nation or people. The Iliad and The Odyssey are obvious examples of the epic—they are book length sagas, written in a consistent meter that lends itself to narrative. However, both these poems most probably had an oral root; that is, they were sung and recited far before they were written down.

In college, I studied folklore and mythology with Professor Lord. He was a short courtly man who raised his hat whenever he recognized a student. As a young folklorist, Lord was convinced of the oral origin of the Greek epics, but no one believed him. Authorities assumed that the works were just too long—who could remember all that? Of course, there was a lot of repetition in the text, people and places were described the same way over and over, but still it seemed impossible that any poet could recite such a work from memory. Mr. Lord went off to collect sagas and songs in the Caucasus Mountains in the 1930's. Here, he found aged bards who could recite from memory the epic poems of their people for twelve or twenty-four hours straight, provided they were given enough encouragement in the form of hot meals and beer. These feats of memory helped prove that the Greek poems were sung before they were ever written down.

Epic poetry is probably the most ancient form of poetry. It tells about a group—who the ancestors were, where we came

from, whom we fought, where we settled. It tells of heroes and demons, of cities, oceans, and battles. Epics don't speak much about individual suffering—or happiness.

The lyric poem tells one person's story—not a nation's. It is a short poem, usually with a condensed emotion. The original definitions of epic and lyric poems were based on different meters, but that distinction is long gone. The great Greek poet Sappho was one of the early lyric poets. She asks a personal question—one no one would ask in an epic: "What is the most beautiful thing in the world?" That is such a good question for poetry you might try answering it yourself. Write down twenty answers quickly and see if you can't make a poem of them. Sappho answers her own question, too. She says the most beautiful thing in the world isn't the horseman dressed for battle, although her glory-seeking contemporaries couldn't have disagreed more with her. Sappho says the most beautiful thing in the world is the look in the eyes of someone you love.

By answering this one question, Sappho pretty much defines the lyric poem. W.B. Yeats said that the only topics for poetry—and he meant lyric poetry—are sex and death. You might add nature to this list, or spirituality, but not much more. If you want to write about how a group of people marries, divorces, makes money, and treats each other, you are probably getting set to write a novel and not a lyric poem. Epic poems are no longer written. It is as if our group consciousness has faded with modern life. The novel now is the place to discuss war and society. The lyric poem is defined by its limitations, of both length and subject matter.

Sounding It Out

The lyric poem gets its life from two techniques—sound and image. Sound of course is linked to metrical lines—it is the music of the poem. Image includes all the techniques that let the poem play out on the inner eye and ear of the reader. The English language is a beautiful one, and in it sound is a complex and sensuous matter. The basis of form in poetry is repetition, and nowhere is this more evident than in rhyme. Rhyme is nothing more than a fully repeated sound. Rhyming the end words of lines is one of the basic poetic techniques in English and the European languages. For many school children, and for adults who haven't investigated poetry very much, poetry is still defined by rhyme despite the fact that there has always been unrhyming poetry. Epic poetry, for example, in any language, does not rhyme. But for the contemporary poet or poetry student, rhyme is an unsolved problem. On the one hand it is the defining hallmark of lyric poetry, and necessary to many forms. On the other, it seems old-fashioned, stilted, and close to impossible to use. But a poet cannot give up rhyme completely. Words do echo each other, nursery rhymes and songs on the AM radio echo in our ears, and no poem can fully exist without musical sound.

By identifying, and practicing, the various techniques of rhyme, or sound repetition, you will eventually be able to control your own use of rhyme in a poem, varying it as you would a recipe. There is a difference between onion soup and a soup that uses a bit of onion for seasoning. Both can be delicious. Know what the soup—or poem—requires in the way of rhyme.

Full Rhyme

This is probably the most difficult rhyme to use. As a school child, before I fell under the haiku writing influence of Miss Penell, I happily rhymed words like "bat" and "cat." Mother Goose uses full rhyme, and so do danceable tunes rhyming "fire" with "desire." However, this gives a thudding predictable effect much of the time in lyric poetry. A better variant is rhyming the last syllables of two words. Rhyme used sparing can enrich a poem, catch the reader's attention, and create emotion. My friend, poet Carol Moldaw, uses rhyme in a way I find particularly pleasing, for emphasis and resolution. Her poem "Beads of Rain" opens with three stanzas that use rhyme sparingly but ends with a fairly formal stanza where every other line does rhyme. Note that many of the rhymes are partial-word ones, rhyming only the last syllables:

Each day I've looked
into the beveled mirror
on this desk, vainly
asking it questions
reflection cannot answer.

Outside, fog and frost
and silver olive leaves.
I can see at most
a half field's depth,
then the trees are lost
in the gauzy mist
like thin unbraceleted arms
swallowed by billowing sleeves.

I'd like to face
that stringent looking glass
transparent to myself
as beads of rain
pooled on a green leaf.

But ever self-composed
in self-regard,
and my eyes opaque
as a dancer's leotard,
to see straight through myself
I need what love supplies:
its dark arrows, dear,
not its white lies.

Moldaw's is a highly contemporary use of full rhyme—she uses it sparingly, and for effect. The poet is conscious of sound throughout—you can read each end word of each line aloud and see how there are echoes between such words as "mist" and "glass." "Frost" and "lost" are a full rhyme; there is what you might call a *visual full rhyme* between them and "most." However, it is the final stanza that relies the most on full rhyme, and because the poet is seeking an emotional resolution the use of sound is particularly fitting here.

Slant Rhyme

This is perhaps the richest form of rhyme upon which to concentrate when you are developing the craft of poetry. It is the use of words that rhyme imperfectly with each other, which echo each other's sound but do not overlap completely. "Silver" and "Deliver" might be an example. There is no particular rule for slant rhyme. Just try to find words that do echo, and they will please the ear. Slant rhyme is also called half rhyme. Searching for rhyme as you write is sort of like learning to drive. At first your conscious mind is busy controlling things. Down shift? Brake? What rhymes with this word? Should I change it? Drop it? Is the rhyme too harsh? Too vague? But quite soon technique becomes unconscious. Just as a driver can soon chat or listen to the radio while driving, with a little practice a poet can rhyme while moving through the poem.

Assonance and Consonance

Assonance and consonance are intimately linked to half rhyme, and often help compose it. Assonance is the repetition of vowel sounds while consonance repeats consonants. Of course you learned as a child that "AEIOU and sometimes Y" are vowels without which no word can exist. Vowels are like carbon in an organic molecule, a defining element. They also have a wide open echoing sound in English. The more repetition and overlap there is in the consonants and vowels of two words, the more opportunity there is for half rhyme.

Masculine and Feminine Rhyme

A poet can't help but be fascinated by the names masculine and feminine to apply to different kinds of rhyme. I don't know much about the origin of the meaning in English, although in the Romance language it seems to apply more specifically to the endings of the words. In the Hopi language rain is also called masculine and feminine, to describe the varying force and feel of much needed precipitation on desert land. Masculine and feminine rhyme also contains this variety. Masculine rhyme is the rhyming of two end words that both stop with an accented syllable. Feminine rhymes rhyme two lines of poetry that end on unaccented—or unstressed—syllables. For the purposes of contemporary poetry, feminine rhyme sounds more flexible and fluid. Use feminine rhyme to avoid a thudding sound at the end of the lines.

Internal Rhyme

One of the most graceful ways to rhyme, and to create a sense of fluid motion in a poem, is to use internal rhyme. This technique rhymes the word at the end of a line with one in the middle of the next. The internal rhyming word is often placed right before caesura, or break. This is a useful

way to gain control of a line of poetry. End rhymes give the line something to focus towards. Internal rhyme strengthens the middle of lines. Combining these techniques creates taut lines of poetry, that are awake in every part.

Alliteration

Alliteration is the repetition of opening consonant sounds in a word. You can create the effect by clustering a group of words staring with "P" or "M" or any other consonant. The Alphabet poem (Chapter 5) is a useful technique for exploring alliteration. This is one more way to create formal sound through repetition in a poem, but is a technique I would use sparingly, as a little goes a long way and too much tends to be inadvertently funny.

Ideas in Poetry

Poetry uses figurative language and techniques, which basically means that it communicates the way dreams do, through the power of symbols and association. There are numerous techniques—called tropes—which are part of the tradition of the lyric. Essentially all of them hinge on metaphorical thinking. The metaphor is basically a comparison, but it is more than that. In our ordinary lives we tend to experience ourselves as separate egos in separate bodies. Western society also tends to see division everywhere, between the worlds of work and play, between men and women, children and adults, between different cultures. Much of our thinking is about dividing and classifying. This way of looking at the world can lead to profound loneliness.

Poetic thinking, or metaphorical thinking, is about connection. The metaphor is always pointing out how things are like each other, not just different from each other. There is a spiritual practice in metaphorical thinking—connecting humans to

nature, the past to the present, and moving out of strict linear time. As you practice the writing of poetry, watch your mind. Your mind will naturally make connections—the taste of plums leads to your grandmother, a newspaper story reminds you of a fairy tale. These little germs are the start of poetic ideas. Jot them down. They often develop into full poems, but the most important thing at first is to notice them. The more you notice, the more they will come.

Simile

Simile is one of the most ancient poetic techniques. It is a device of comparison, using the words "as" or "like." In the Greek epic poem *The Iliad* the warrior Achilles comes down on his enemies "like a lion." A simile works in two directions simultaneously. Achilles is like a lion, but a lion is also like a hero: bold, kingly, dangerous. Similes present a problem to the beginning poet. They are often so shopworn as to be straight-out cliches. You obviously do not want to compare your true love's lips to cherries. But comparing them to the red of cherry cola or to killer red high heels might be better. Better still, take a good look at your true love's lips. What color are they really? What do they taste like? Bubble gum? Pepperoni? Stretch the simile.

One way to do this is through the "Laundry List" approach. For list A, write down ordinary human activities, whatever comes to mind:

> washing dishes
> riding a bicycle
> tickling a child
> eating an apple
> sharpening a pencil

And for list B, write some observations from the natural world. Try to be as specific as possible:

a sunset over the Atlantic
apricot blossoms
hill of red ants
piece of mica
dandelion in a crack in the sidewalk

Now, for your simile, take one item from list A and one from list B. Maybe the combination will seem weak, maybe unique and interesting. Try combining "Biting into an apple is like a sunset over the Atlantic." The two images share the color red and a sense of sharpness or pungency. For contrast, there is the sense of taste and the sense of seeing. Even wilder, "Biting into an unripe apple is like stepping on a hill of red ants." Or go even further: "Sharpening a pencil to write harsh words/like a hill of red ants." Create your own lists and similes—don't be afraid to just fool around until something truly catches your interest.

Metaphor

The Romantic poet and critic Coleridge said that metaphor is the "linking together of disparate elements." Metaphor is a comparison that does not use the word "like" or "as." In some ways, the metaphor is more basic to poetry than the simile—it makes a more intense and powerful comparison. For example, Achilles is not just *like* a lion, he actually is a wild beast. Feel free, however, to use simile and metaphor interchangeably as you write. Their similarities, in terms of poetic thought, are greater than their differences.

In the following short poem by Anne Valley-Fox, the major poetic trope is the metaphor, both obvious and implied:

New Year's Resolution

Hike to the nape of Moon Mountain in ice
bright air; stand
on the giant's shoulders and say *thank you*

Here, the mountain is compared to a giant, and the poet is tiny beneath the peak. The implied metaphor is between the resolution of the title and the hike itself, both reflecting difficulty. After I'd read the poem many times I also began to sense a metaphor between the New Year's resolution and the "thank you," as if Valley-Fox had resolved to be more grateful to the earth around her.

Image

An image is any condensed sense perception used in a poem. Poems that depend almost exclusively on image can be described as "imagist." As you work with images, think of your mind as a screen upon which scenes are being projected. Your work as a poet is in part to let the reader see what you see, smell what you smell, and by extension, feel as you feel. The human mind is highly associative. The poem is a controlled link between the poet's mind and the reader's.

This short poem by Elizabeth Searle Lamb depends almost completely on image, and contrast, for its effect.

Search

stumbling
onto her body
in the ditch
white butterflies

The poem deals with the tragic and frightening event of the murder of a local woman. The poet imagines the finding of

the corpse in an irrigation ditch. The sudden image of death is contrasted to the flight of butterflies, which is at once realistic and also an image of life or rebirth. The poem exists, though, without overt philosophy—the emotion is held by the images. A slightly longer poem that depends purely on imagery for its effect is Leo Romero's poem "Cabezon," written about rural New Mexico, which is almost a photograph in words:

> A small adobe church
> with wooden roof and tower
> cross perched
> A few adobe houses
> Raining
> Difficult to keep the car
> on the clay road
> A ghost town
> below Cabezon
> an immense volcanic plug
> rising straight up
> from a shelf
> Cabezon the town
> Cabezon the peak
> For miles no one
> just the clay road
> the rain
> the swerving car
> the adobe houses
> gathering about the church

Of course in Leo Romero's poem there is an emotional association as well as pure image. The vulnerability of human life is seen everywhere, from the ghost town to the dangers of driving, and those small houses huddled around the church seem to reach out for sustenance. Alvaro Cardona-Hine in his series "Poems from Memory's Village"

40

moves more obviously from image into comment on human life. In Number Eleven of the series Cardona-Hine, who is also a painter, draws a landscape. He is observing his neighbors in the still remote mountain village of Truchas, New Mexico. "The Sangres" referred to are the Sangre de Christo Mountains, a foot of the southern Rockies. By the end of the poem, the poet moves away from image completely, and into direct speech and observation. This movement, from visual to idea, is a trademark of modern poetry:

 here the cemeteries
 plunge
 down the mountain
 one is sure to be
 buried
 standing for rigor mortis

 if you are a member
 of this or that clan
 you'll have a backyard
 full of plastic flowers
 below the open beak
 of the Sangres

 those who can afford it
 celebrate dying with taffeta skirts
 with the lips of lilies
 the poor are buried in some socket
 of ignorance

 ignorant
 until the last minute
 when they let out a scream

 it's such a relief to die
 when you have given birth
 to so much that is
 nothing

Most poems, except for very short ones, will use more than one image. When you work with multiple images, continue to use the rules of metaphor and simile. Coleridge's disparate elements should not be so close they require no yoking, nor so different that they don't make sense hooked together. Remember again that images do not need to be purely visual. Santa Fe poet Mary McGinnis was blind from birth, yet writes work full of sense imagery. I once heard her describe a woman's voice as being "like cherry bark tea." Here sound and taste are combined in a simile. The average person in our society leads with only two senses—seeing and hearing. It would be considered rude to come into someone's house and to literally "smell" the situation out, although that would be second nature to a dog. Don't be afraid to use the "less polite" senses—smell, taste, touch—when thinking metaphorically. The liberating effect of words is described in Mary McGinnis's poem:

Reading Braille

I read and dreamed of wild dark places near the water,
pearl divers who dove for pearls and had seaweed on
 their arms;
I was not at home in my body then,
and I read until my fingers were raw....

The crossover between the senses is called synesthesia. Try this experiment. Roll your eyes up, then close your lids. Tap gently on the closed eye with your finger. You may see a flash of light. Your eye is capable of translating touch as vision. Synesthesia means one sense is experienced as another. Write a poem that answers some of the following questions: What is the smell of loneliness? What is the sound of spaghetti? What is the taste of rubies? What is the touch of the Milky

Way? Make up your own questions using synesthesia, and answer them. Don't be afraid of looking silly; you are trying to expand the metaphor-making part of your poetic brain.

Hyperbole, Conceit, and Allusion

The use of figurative language in lyric poetry is essentially unlimited, but there are certain techniques worth noting and practicing from time to time. I've selected the ones most useful to the contemporary poet—tropes, which work to expand the consciousness of the poem. Hyperbole, or exaggeration, is a natural part of metaphorical thinking. Exaggeration can be boasting, or the claiming of magical powers, or emphasizing the undying or extreme qualities of an emotion such as love. In these ways, exaggeration taps into the divine. The poet becomes a magician or shaman, at least for the space of a few lines. I once spent more than a week snowed-in at a remote Benedictine monastery where the monks were under a vow of silence. The guest quarters were tiny and dark in the vastness of a river canyon. Writing by a kerosene lamp or lying for hours on a pallet like bed, my consciousness began to alter. I wrote a long poem about it, with a section starting: "Every night I fly over Tibet/Every night I fly over Chama, New Mexico." Exaggeration may bring you closer to the truth found in non-mundane realities.

Poems also have an intellectual component. The poem is not a philosophical or scientific tract, and often a poetic idea is no more complex than that time and history wear away our perceptions of the moment, or a comparison of a large concept such as black holes or quasars to a smaller human concern. A conceit is essentially a metaphor or poetic idea that extends throughout the entire poem. It is intellectual in nature and can be regarded as a poem-long metaphor.

An allusion is a reference to something outside the insular world of the poem itself—a reference to history, myth, science, or some other body of human knowledge. Again, the allusion is essentially metaphorical. Poems vary a great deal in terms of how much allusion each uses. The standard issue contemporary poem uses very little: the poem is its own tight imagistic room without too many windows looking out. The Romantic poets, however, were allusion crazy—everything reminded them of something else, whether it was the myth of Prometheus or the French Revolution. Don't be afraid of allusion; after all, you know more about the world than just about poetry. My poetry tends to be full of jumpy allusions, so I am prejudiced in the trope's favor. Even if you aren't drawn to it, force yourself on occasion to refer to something outside the poem, whether to current events or a fairy tale.

Personification

Personification is the technique of taking something non-human and giving it human attributes. Frankly, this trope seemed completely lifeless to me until I encountered an exercise in personification in a poetry class taught by Joan Logghe. Joan had each student pick an abstract noun—Death, Hope, Spring, War, Peace, and personify it by answering the following questions:

> What does it wear?
> What does it smell like?
> What does it say?
> What does it eat?
> How does it make a living?
> What does it dream about?

Much to my surprise, I wrote a complete poem in her class, that begins "Death wears an overcoat /...a New York City

44

coat/Black wool/Goes with everything/Always appropriate" and moves on to "Death plays the violin/Death is a panhandler/Death works for UPS/Death works for the CIA/Death loves initials/Death monograms things for mail order catalogues/Death comes to America/To find a better way to make a living." Joan Logghe's exercise seems to work for anyone who tries it. I've even seen a fabulous poem written personifying the abstract concept of deja vu. The trope of personification, used properly, animates the abstract with the specific.

A different kind of personification, but interestingly also of death, is found in the work of Tony Mares (E. A. Mares). In "La Coqueta" he works with a traditional northern New Mexico figure of death, Doña Sebastiana, who is usually portrayed as a wooden figure of a skeleton, often sitting in a cart, sometimes armed with arrows. Mares opens the poem with the technique of a list poem—listing death's names in Spanish. He goes on to recount several brushes he has had with her, ending the poem with a litany, another list, which describes her attributes:

Come Bony-Faced Woman,
Skinny One, Skull Face,
Bald-Headed One, Bitch,
Stinking One, Toothless One,
Soot-Covered One, Sour Face,
Screwed-Up One, Rascal,
Grim-Faced Aunt Sebastiana

and so on, invoking Death even as he maligns her. The poem ends with the poet in Death's arms, dancing, in an image that comes to us from as far away as Medieval Europe:

Come, let us dance
On and on together,
Always laughing and dancing,
We're two of a kind.

Leo Romero uses the same traditional figure of death, but treats her as more of a character among several in his poem "Doña Sebastiana." One of the reasons that both this poem and Mares's poem work is that they draw on a figure of a abstract noun, Death, that has already been personified in folk lore and popular imagination. The figure is a familiar cultural one, but the poet must breathe excitement into it to keep away from using a cliche. In Leo Romero's poem Doña Sebastiana comes without her cart, but retains her speed and motion:

The last visitor
my grandfather saw
was Doña Sebastiana
My grandmother
did not want to let her in
but the door flew open
My grandmother
did not look at her
but sat by the wood stove
and held tightly to her apron
like a little girl

Doña Sebastiana passed by me
so quickly
that I could not see her face
She looked neither at me
nor at my grandmother
but went directly to
my grandfather's room
Her robes fluttering
about her like wings

For many nights afterwards
I would hear a horse
gallop wildly past the house
I never told anyone
about this
and especially not
after my grandfather died

One of your major practices as a poet is to think metaphori-
cally. Use whatever time-honored techniques you can to
continually draw connections between realities inner and
outer—for yourself and for the reader. Metaphor is the
spiritual essence of any poem.

CHAPTER 5: OPENING WORDS

I once showed a long poem I was quite pleased with to poet Philip Whalen. Phil was a friend of my husband Robert's; he was an enormously fat man with the clean shaved head of a Zen priest. He was eccentric in both appearance and manner, and I was somewhat afraid of him. His reputation, too, intimidated me. One of the original Beat poets at San Francisco's Six Gallery reading, he was the model for one of Kerouac's characters and a poet admired by Allen Ginsberg. However, when I found myself living near him in Santa Fe, where both he and my husband had moved to study with the same Zen teacher, I found him less frightening. We fell into domestic routines together, going to the laundromat, eating at the funky old Mr. Steak, and watching endless *Doctor Who* reruns on public television. After a few months, I felt brave enough to show him my opus.

Phil read it promptly, and returned it to me adorned with penciled comments, which were mostly doodles of skull and crossbones. He'd marked every line he hated in that fashion. Then he'd drawn a line to marginalize the opening word in each line. Taken together, these words looked terrible. It was a list of dull short words, such as "and," "but," and "the." There were almost no strong verbs or nouns, no words that sparkled with color or delivered a dynamic punch.

I had spent the first fifteen years of writing poetry concentrating almost exclusively on the end words of each line. After all, the end words of lines are where much of the action is— whether it is full rhyme or half rhyme or just an echo of sound. The ends of lines too are where the poem pauses for breath,

and where the poet debates each line break, shaping the poem.

To rectify the situation, I first tried to simply become aware of the opening words of each line. I then began to look for formal techniques that would help build the opening of the lines.

Anaphora

Anaphora is a Greek term and an ancient poetic technique. It simply means to begin each line, or every few lines, with the same word or phrase. Repetition is the basis of all form in poetry, and anaphora is repetition at its most basic. In conversation repetition can be boring—think of how everyone cringes when Uncle Max tells the same story *again*—but in poetry it is essential. Interestingly, repetition such as anaphora or a refrain will not stay stagnant. Rather, the repetition is soothing and becomes familiar to the reader. It also accrues new and different meanings as the poem progresses. You don't need to aim for this effect directly; just follow the repetition of the form and allow it to happen naturally. One of the finest examples of anaphora in contemporary poetry is Joy Harjo's signature poem "She Had Some Horses." Read it and note how the repetition moves and changes. Another fine example is from Arthur Sze's poem called "Here." "Here" is the word Sze chooses to repeat:

> Here a snail on a wet leaf shivers and dreams of spring.
> Here a green iris in December.
> Here the topaz light of the sky.
> Here one stops hearing a twig break and listens for deer.
> Here the art of the ventriloquist.
> Here the obsession of a kleptomaniac to steal red pushpins.
> Here is the art of the alibi.
> Here one walks into an abandoned farmhouse and hears a
> tarantella.

Here one dreamed of a bear claw and died.
Here a humpback whale leaped out of the ocean.
Here the outboard motor stopped but a man made it to this
 island with one oar.
Here the actor forgot his lines and wept.
Here the art of prayer.
Here marbles, buttons, thimbles, dice, pins, stamps, beads.
Here one becomes terrified.
Here one wants to see as a god sees and become clear amber.
Here one is clear pine.

The effect of the poem is both incantatory and mysterious. Sze starts off with very physical images, but ones that mix seasons. The work becomes wild, more abstract, crossing boundaries, where the reader moves from a bear claw to a whale as if in a dream or hallucination. The end leaps forward with a transcendent quality, moving from prayer to a mundane list of objects, then back to the divine. The technique of repetition holds the poem together, grounds it, and creates a kind of steady metronome or beat against the wildness of the associations. Note too that there is a mini-list contained in the poem, and that the whole poem has the effect of a list.

You can use this simple technique to ground yourself in any particular place and time—and to bring the poem into the present. One way to start is to pick a color, such as green or blue, and begin each line with it. Let your imagination run wild as you work, and try to stay away from the obvious. A line "Blue as the sky" is a cliche, while "Blue as Tibet" is less expected. Let the rhythm of the poem build but continue to return to your front word color. This will create rhythmic intensity in the poem. Go on and try a less usual color, too, such as violet or azure.

For a more complex use of anaphora use a phrase as an opener. It can be something like "I want," or "I hate," or "I need." This can generate some fascinating poetic material, particularly if you are willing to try it for at least ten to twenty lines. To strengthen the actual front words themselves, go into the command form: "Give," "Remember," "Love." Allow the phrase to vary gently as the poem evolves, but continue to concentrate on strong openings.

Know Your ABCs—the Alphabet Poem

When my daughter was young, I used to enjoy reading books to her of the "A is for Apple" variety, in which each letter of the alphabet refers to some object. As a harassed young mother, I was always looking for ways to steal time and energy for poetry away from child care. But it was in these alphabet books—hard backed, brightly colored, often sticky with mashed banana—that I found a source of inspiration.

The alphabet itself has a soothing narrative quality, in part because as children we enjoyed learning to recite and sing it. And the alphabet has its own weird magic. As a child, I believed that somehow the alphabet was in a *real* order, as if the letters had a quantitative relationship like numbers. I also could not recite it without speeding over L-M-N-O-P because that was the way the alphabet song went. Alphabets in many cultures have a mystical meaning as well. The magic phrase "abracadabra" comes from the opening of our alphabet, and each letter in the Hebrew alphabet has its own esoteric significance. Therefore, to follow the alphabet is to follow an inevitable seeming road, where B must follow A and where X Y Z come as surely as fate.

You can make a challenging—but satisfying—poem by starting each line with a letter of the alphabet, and working from A to Z. Feel free to make obvious that you are working in this

form by capitalizing the alphabet or announcing "A is for...."
The reader will enjoy both the predictability and, of course,
the way you vary, the form. I have had a great deal of fun
with this form over the years and have written alphabets of
angels, of prairie flowers and grasses, and just of images
that are inspired by the sequence of letters. The deeper
you get into the alphabet form, the more character each
letter has.

You can explore this in a variation of the alphabet poem by
taking just one letter of the alphabet and using it as the
basis of a short poem. You might start with the first letter of
your name or a consonant whose sound appeals to you. Then
use as many words as you can that start with that letter. This
guarantees strong—and interesting—front words for each
line. The technique also allows you to develop a smooth,
full sound, whether of vowels or consonants.

The Acrostic

The technique of using one letter of the alphabet develops
naturally into the acrostic. An acrostic can be treated as a
kind of poetic game or puzzle, but in actuality it is a more
profound use of craft than that. Acrostic is also a Greek word,
which essentially means front or outer words. An acrostic poem
is one in which the first letters of the lines, read down, spell
out a message—be it a word or longer. This form certainly
appeals to crossword puzzle fans, but it was also used in the
Hebrew psalms and by Medieval and Renaissance poets. It
adds a quality of mystery to a poem, which is not unrelated
to the mystery of the alphabet itself. Remember that the
word "spell" has an important double meaning. It means
not only to spell a word correctly but also to put a charm
or hex on something. The acrostic contains a hidden

message, a kind of magical incantation buried by the poet and discovered by the reader.

An easy way to start an acrostic is to write your full name down the left hand margin of the page. Treat each part—first, middle, last—as its own stanza. Now, begin to fill in the letters with rich interesting words. You may need to break the lines in unusual places to keep the sense going, because the strong words are all at the start. This poem is sure to tell you something about how you feel about your name, and your self. Using your own name in poetry is always a powerful practice. A poet should be obsessed with names—the correct names of plants, animals, stars. Putting your own name in a poem is very grounding, and although it may originally feel weird or egotistical it adds an almost physical piece of magic to a charm.

An acrostic makes an intriguing valentine or message poem. I've enjoyed writing acrostics based on their names for each member of my family on special occasions. Acrostics seem especially good for messages of love, or for something you are almost too shy to share. In the double acrostic, the last letters of each line also spell out a phrase.

Make a List

I've always loved the riff in the science fiction novel A Canticle for Lebowitz which is about a list. An ordinary list, which includes buying bagels, is preserved after a holocaust destroys most of the world. The earnest monks of a new Dark Ages examine this list religiously to discern its meaning. I once came upon an old list of my own, which fell out of a book. The randomness of "buy tampax" next to "finish Pablo Neruda" brought back the concerns my younger self.

We all make lists every day, whether of things to do or groceries to buy. A list of course emphasizes the start of each line, both by using numbers and by focusing on strong words. The most enjoyable way to start a list poem is by finding a great title you can work with. Set out the expectation in the title and then deliver in the list itself. I once wrote a poem entitled "The Eight Most Boring Days of My Life," which was not only funny but rather poignant, as I scoured my memory for dull rainy days at the beach and childhood feelings of loneliness. Your titles can range from something like "Seventeen Things I Love About Your Face" to "The Most Beautiful Things I've Ever Seen" to "Nine Foods Children Won't Eat" to "What Makes Me Angry." Don't be afraid to be specific, and personal. The poet Alice Notley, when she was a recent widow living in Manhattan with two small children, created list poems of the greatest animals—or super heroes— in the world. Her children collaborated with her on these, and probably helped her—as the alphabet poems did me— to integrate motherhood and poetry.

One of my favorite list poems "What Was There to Do on the Plains" is by New Mexico poet Leo Romero. The poem starts off with a simple list:

> Drink beer, drive 90 miles per hour
> Drive down dirt roads without signs
> Crisscrossing New Mexico and Texas

but soon intensifies:

> Run over turtles day and night
> without meaning to, run over
> jack rabbits without meaning to
> Buy a large turquoise colored belt
> and have your name put on it

Marvel at the immense skies
Watch the sun set over the wheat fields
Count telephone poles from Yeso to Vaughn

You can use this technique to good advantage and make your own list: "What There Was to Do in San Francisco in the Fog," "What There Was to Do in the Helsinki Airport," or "What There was to Do on My Grandmother's Front Porch," or "What There Was to Do in Bed."

Note that in Leo Romero's poem there are some repeated front words, some exciting ones, and a few mundane ones. The goal is not to have *every* opening word be strong and unique, but rather to become aware of the potential of this area of the poem. You can make yourself crazy by deciding that every start word—or indeed every word!—in the poem must be brilliant. It is instead that you want to be able to apply your attention to the start as well as the end of each line.

CHAPTER 6: THE BALLAD

Common Measure

Of all the traditional forms of poetry, the one that is probably the most familiar to our ears is the ballad. We hear it without realizing it, because most songs are written in it. Most of the times you hum along to the AM radio or listen to an old Beatles song you are unconsciously taking in ballad meter. Nursery rhymes are also written in ballad meter. So are the Blues, as well as many traditional hymns. From Bessie Smith to Mother Goose to John Lennon, poets of the English language rely on the ballad as perhaps the most serviceable form. It is also the only form left in English that is still intimately connected to music.

The formal constraints of the ballad are meter and quatrain. Ballads are written in four-line stanzas. The first and third lines have four beats or stresses out of a possible six to eight syllables. The second and fourth lines come down to three beats out of the same syllable range, and they rhyme with each other. In some cases, lines one and three also rhyme, but this is not necessary. The classic ballad in English originated in England, Scotland, and Ireland. It migrated to the United States, where it was sung particularly in Appalachia. There ballad measure was picked up by African-American singers and, with some variation, turned into the blues. There are also ballads in all of the European languages. Ballad measure is also close to, or identical with, the meter known as common measure. Some purists differentiate between common measure and ballad measure by saying that common measure, while using the same rhyme scheme, always uses iambic pentameter—that is, five stresses out of ten syllables. However, observation leads me to conclude that in the last

fifty or a hundred years the two measures have pretty much merged in usage in the United States. Ballad measure itself has always been fairly loose—so feel free to vary it once you get started.

All this talk of meter and stresses may seem daunting at first. It is confusing for many poets first starting out to realize that poetic forms exist in the abstract, like grids or maps or mathematical formulas. But it is useful to accustom yourself to thinking this way. The traditional forms are simply like recipes, time honored and tested. It now becomes up to you to start adding what your grandmother might call "a pinch of this" or "a handful of that" to make the form your own.

Make a Ballad of It

We can make a grid for ballad measure and then examine a few examples. Note that the end words of each line are labelled "rhyme" although lines one and three do not actually rhyme with anything. But it is good to know where your potential rhymes are, in case you want to structure in some internal rhyme or slant rhyme.


 X X X X (Line 1. 4 Beats. Rhyme A)
 X X X (Line 2. 3 Beats. Rhyme B)
 X X X X (Line 3. 4 Beats. Rhyme C)
 X X X (Line 4. 3 Beats. Rhyme B


Note that the stressed syllables or beats have been arranged casually, in no particular order. I feel that for the contemporary poet it is probably best not to put a strait jacket on the meter. However, it is common in the ballad to stress the last syllable of each line, which of course will also occur naturally through the agency of rhyming.

What does this look like with actual poetry? Take this haunting quatrain from *Mother Goose*:

> How many miles to Babylon?
> Three score and then,
> Can I get there by candlelight?
> Yes, and back again.

Note that lines two and four rhyme. Count the number of syllables in each line, and try to notice where the beats are. Most important, see how the form is handled loosely, even in a classic example.

The greatest source of ballads is a collection made in the nineteenth century by a folklorist named Francis James Child. Child wrote down hundreds of folk ballads from the Anglo-Irish and Scottish tradition. You can find his collection, *The English and Scottish Popular Ballads*, in any good library. Reading old ballads is surprisingly exciting, for they deal almost exclusively in thrilling and horrible tales—murder, pirates, unquiet graves, lovers who turn on each other, homicidal sisters, missing body parts, infanticide, poaching, and revenge. In fact, modern day suspense and horror novels have little subject matter that isn't covered in traditional ballads, which also emphasize the supernatural, ghosts, and the return of the dead. An excellent way to become acquainted with the traditional ballads is to get a copy of Joan Baez's double album, which features her singing these classics of mayhem and betrayal. It is as if the serviceable, plain form of the ballad lends itself because of its very simplicity to telling a thrilling tale of woe.

The literary ballad is the work of one poet, as opposed to the folk ballads, whose authors are unknown and which probably changed and developed over time. When you set

out to write a literary ballad, you are following in the steps of such poets as Coleridge, whose "Rime of the Ancient Mariner" uses the ballad form—and its supernatural subject matter:

It is an ancient Mariner,
And he stoppeth one of three.
By thy long grey beard and glittering eye,
Now wherefore stopp'st thou me?

Coleridge loved the old ballads, and even introduced another poem of his own, "Dejection: An Ode," with a quatrain from the Child ballad "Sir Patrick Spence":

Late, late yestreen I saw the new Moon
With the old moon in her arms;
And I fear, I fear, my master dear!
We shall have a deadly storm.

Investigate both Coleridge and "Sir Patrick Spence." Note the rhyme scheme, count the syllables. And don't forget to feel the poem, how the simple form manages to convey something mysterious and enticing. I sometimes find myself counting syllables along to the meter of a Bruce Springsteen song or something else on the radio. When you can hear the stresses and rhymes quite naturally, you will have mastered the ballad form.

A nice contemporary usage of a variation on the ballad form is found in Carol Moldaw's "Reb Shmerl and the Water Spirit." Moldaw took an old Hasidic tale from Eastern Europe and retold it by putting it in one of the best poetic forms for narrative—the ballad:

Reb Shmerl, a peddler from Constantine,
thought he had found a way to sin

and keep his yearly slate as clean
as clouds, the suds God washes in.

He grabbed up sins at all his stops,
carted them home without a thought,
tossed them down the cellar steps,
slammed the door, and let them rot.

Shmerl raked up his sins each fall,
and stuffed them in a burlap sack
he rolled down to the lake, a ball
that sank like lead. The lake turned black.

Of course the reader rightfully expects that this system of
Reb Shmerl's is not going to work in the long run; the
suspense and the conflict are already in place. Moldaw uses
the rhyme scheme ABAB. This is a useful variant on the
ballad form, although stricter, and can essentially be con-
sidered rhyming quatrains. Most of the lines in the poem
run about eight syllables. When you first begin to write
ballads, rhyme only the second and fourth lines. First of all,
this is traditional, second of all—it is easier and less con-
stricting. However, to truly develop rhythm and sound in
your poetic ear, rhymed quatrains are a useful technique.
You can also flow between the two in the same poem

What is your best subject for a ballad of your own? Any story
you want to tell may work, particularly if the story has a
magical element. It can be serious, talking about an abandoned
light house on Cape Cod that one stormy night lit up your
way home. Or it can be humorous, describing the time you
and your friends were convinced you had the ghost of Lee
Harvey Oswald at the seance. (I don't know why we did this
when I was a kid—but we did.) Another traditional subject
for a ballad is a contemporary event. In Elizabethan times,
ballad makers stood on corners, hacking out verse on the

scandals of the day. The ballads, printed on cheap paper, were the newspapers of the time. Shakespeare even has a character remark about some lurid event that "they will make a ballad of me." A ballad can attack a president's peccadilloes or address the more serious subject of war or oppression. If you read something in the newspaper and are moved to say something but don't know how to say it—the ballad form may work well to unloose your voice of social protest. For all these reasons, the subject matter of the ballad is not usually highly personal, but more of a story-telling voice. The Blues, which bear a formal relationship to the ballad, are more individual.

You Gotta Pay Your Dues—the Blues

The blues draws its roots from African music and the ballads of the American south, which are Anglo-Irish in origin. African-American singers developed the blues form out of work songs that often had a refrain hollered back and forth. Work songs, whether for farming or fishing, are the basis of a great deal of poetry, because they have a highly rhythmic component to help people pull together. The most ancient poems in Chinese, which form the earliest part of that canon of literature, are thought to have come from work songs. The traditional blues form is a variant on the ballad: lines one and two are repeated for effect, but it is still lines two and four that rhyme. You can see this in a classic from Robert Johnson, maybe best known to you by the cover done by the Rolling Stones. Robert Johnson was the mysterious bluesman who sang and died in the south in the 1930's. He is credited with reinventing the blues, putting a highly personal stamp on music and on lyrics that are often tortured and demon ridden:

> When the train it left the station
> with two lights on behind

When the train it left the station
 with two lights on behind
Well the blue light was my blues
 and the red light was my mind
All my love in vain
All my love in vain

Throughout this stanza, repetition builds up emotion. It also, like all repetition, helps create a sturdy and expansive form. Johnson also uses a hallmark of song-writing and ballad-making everywhere: the refrain. The refrain is a line or lines tacked on to the body of a ballad, repeating in a pattern, such as once per stanza. In some songs, the refrain may be an entire quatrain. The effect of all this repetition is a haunting creation of an emotional state, or emphasis on a moral or meaning. Also, as you'll notice if you sing a children's song along with some kids, the return to the refrain is familiar and reassuring, like turning the corner and seeing your own house again.

The blues, like the ballad, has both its folk form and its literary one. The literary blues are written on the page, without music. Some of the finest examples can be found in the work of Langston Hughes, father of the Harlem Renaissance. If you want to write your own blues, follow the traditional form if it works for you. The blues of course is a good way to express suffering—lost love, bad times, money troubles. It is a great—and sanctioned—way to complain. Pick something that is driving you crazy—bad drivers, bad weather, bad landlords—and go for it. If the form loosens a little, or uses less or more repetition, don't resist. The more you use it, the more any form will change to accommodate you—and your particular subject matter.

The Yellow Rose of Emily Dickinson

All of Emily Dickinson's poems are written in ballad form. Take a look at her selected or collected work and notice how she uses it. There are some similarities between Dickinson and Robert Johnson. The differences are more obvious—she was a woman, a white New Englander, upper middle class, educated. He was an itinerant Black man, a Southerner, who died a violent death. But both of them are quintessentially American. Both of them wrote highly personal lyrics of both beauty and despair. It is no accident that both of them are masters of the basic American form— the ballad.

Here is a trick with which you can horrify or amuse fellow poets and friends. Try singing a poem of Emily Dickinson's to the tune of "The Yellow Rose of Texas." The reason this silly trick works is because of ballad measure. But it isn't just a trick—it shows the connection that still exists between poetry and song.

Any poetic form has been burnished with use and age. You can think of a great poetic form as a perfectly seasoned salad bowl, wiped with garlic and olive oil daily for many years. Or as your grandfather's set of hand tools, perfectly clean and oiled, hanging in the garage, ready for use. When you attempt the ballad, at first it will seem as if the form is in charge of you—spinning your brain to meet all its requirements. Eventually, with practice, you'll spin the form to your own use. Write a ballad about a current event. Run at least ten to twenty verses, without a refrain. Write a short blues piece, complaining about where your money goes. Repeat lines for emphasis. Then sit down to write an imaginary tale on the supernatural or divine. You can start in the real world,

then fall into a dream. Let the ballad form loosen, use half rhyme where you like, and don't count the syllables too strictly. See if practice cannot help you make this form part of your poetic repertoire.

CHAPTER 7: THE PANTOUM

Obsessive Compulsive

As a poet, or a writer of any sort, you must use your own obsessional material. At first it may not be that obvious what your own obsessions are, but the more you write the more you will see your recurring material appear. Obsessional material is not something you choose—it chooses you. And it may not be pretty or neatly packaged or present the face you want to the world. Over the years I've found my poetic obsessions and even watched them change—images of flying and escape from my childhood, a fascination with the desert landscape of the biblical Exodus, love and sex in all its forms, the death of my first husband. To be honest, on most days I really don't want to write again about being widowed or about the view of the Hudson River that is my first memory. But you cannot censor obsessional material, or you will block completely. In fact, once you realize you have obsessions, welcome them, because they are a rich foundation for poetry.

No one wants to be stuck completely, though, on well worn mental pathways. In graduate school I studied with the critic Helen Vendler, who though essentially a formalist had a lot to say about the Romantic poets. She observed that the poet Keats was so great—despite the fact that he died so young—in part because he wrote in bulk. He wrote right through his faults and obsessions—line after line after line—until his poetic vision was purified.

Like Keats, you need to start writing frequently and massively. One excellent exercise for dealing with obsessional material is to write a long—*long*—autobiographical poem based

on childhood. Decide to go for at least a hundred lines—that is over three pages—and address some or all of the following themes: What is your first memory? What are the early houses and apartments you lived in? When did you first hear someone lie? What did you eat as a child? Did you have a special hiding place? Secret treasures or objects? Who was your first love? Did you ever run away from home, even briefly? When did you first realize you believed in God? Or stopped? What was your first kiss?

There is a fascinating concept in the Buddhist religion that in order to be a bodhisatva—a compassionate being—you must have the childhood of a bodhisatva. Of course, most of us don't have childhoods that would lead us to become saints of any sort. The same is true of poetry—to be a poet you must have had the childhood of a poet. What does that mean? It means you must recover your sense impressions from the time when they were the most vivid. Your childhood may have been happy, unhappy, or downright traumatic. None of this matters—poetry is not therapy. You want to be able to taste and touch childhood. This will serve as one of the greatest wellsprings available to your work.

A *Slinky*

Certain forms also lend themselves to the exploration of obsessional material. The best of these is probably the pantoum. The pantoum comes into English from the Malayan. Like the ballad, the pantoum is written in quatrains, and was first oral—a form that derived from fishing songs—before it was written down. The pantoum, or *pantun* as it is called in Malayan was first picked up in Europe by the French poets, including Charles Baudelaire. The New York school poet John Ashbery introduced it into the American mainstream in the mid 1950's, when he began

publishing and teaching the form. I learned the form from Jane Shore, who had learned it under Ashbery's influence, when I studied with her as an undergraduate. I was immediately fascinated by its seemingly endless repetition. I teach it in every writing group I lead, and students love it because it is an instant—if highly spontaneous—way to give a poem a sophisticated, musical, and pleasing form.

Here is the grid for the start of the pantoum:

```
_____ (Line A)
_____ (Line B)
_____ (Line C)
_____ (Line D)

_____ (Line B)
_____ (Line E)
_____ (Line D)
_____ (Line F)

_____ (Line E)
_____ (Line G)
_____ (Line F)
_____ (Line H)
```

And so on for as many stanzas as you want to write until the last, which has its own special form.

The method of composing a pantoum is simple yet elegant. You first write a stanza of four lines. The pantoum will work best if the lines are fairly intact—each expressing just one basic idea or image. In the second stanza, it is time to let go of the idea that you can control the pantoum. You cannot control its flow, or even its sense completely—instead, you must allow the wave-like quality of the form to carry you along. This is because of the nature of the pantoum's

repetons—the lines that repeat. In the pantoum you simply pick up lines 2 and 4 of the first stanza and plunk them down as lines 1 and 3 of the next stanza. I always write out the *repetons* first. The good news is—you have already written two lines of the quatrain. The more frightening news is that you now have to connect the *repetons* with new lines. Don't think too much here; spontaneity will help you, and it is probable that your first impulse about what to write is the best.

The pantoum continues in the same fashion—lines 2 and 4 pick up and repeat as lines 1 and 3. I have alphabetized my grid, but you can number yours if that works more clearly for you. I always visualize a pantoum as a slinky going down a flight of stairs—it is smooth, fluid, and repetitious.

One of my favorite contemporary pantoums is by poet Joan Logghe:

High School Graduation Pantoum

The dark boy leans against his pickup truck.
His heart widened into Romeo since he met my daughter.
I say to myself, "It's not worth creating a tragedy."
With the Blood Mountains behind them for Verona.

His heart widened into Romeo since he met my daughter,
a girl pulling him by the arms down the driveway
with the Blood Mountains behind them for Verona,
the wild plum blooming, they will make sour fruit.

A girl pulling him by the arms down the driveway,
not long ago, her arms reached, her face ached red for me.
The wild plum blooming, it will make sour fruit.
Passion so sweet, grape couldn't turn wine without it.

Notice that Logghe starts her pantoum with a quatrain in which each line ends with a period. But the lines start to soften and loosen as the poem continues. Her repetition is quite exact at this point in the poem, although some poets will vary the *repetons* slightly as they go, perhaps using a pun or different sense of a word. If you feel you must vary for effect, go ahead and try it, but not so much that you alter the integrity of the pantoum form.

Logghe's pantoum continues:

> Not long ago her arms reached, her face ached red for me,
> crying through play-pen bars as I gardened
> passion so sweet, grape couldn't turn wine without it.
> I thinned lettuce, her stomach full of milk and need.
>
> Crying through play-pen bars as I garden.
> Time is a rascal magpie pecking at the corn.
> I thinned lettuce, her stomach full of absence.
> I sat next to her driving, yelling, "Brakes!"
>
> Time is a rascal magpie, exotic in the corn.
> A yogi asked, "What if this baby should die?"
> I sit next to her driving, yelling "Brakes!"
> My heart beats audibly past midnight curfew.
>
> A yogi asked, "What if this baby should die?
> Her tongue is long." He wrote on his slate at Lama Mountain.
> My heart beats audibly past midnight curfew.
> At Christ in the Desert I cried in the chapel for loss.
>
> Her tongue is long, he wrote on his slate in silence.
> She's kissed a boy she loved and some she didn't.
> At Christ in the Desert I cried in the chapel for loss.
> I sat with older mothers who had moved on.

Joan Logghe is now at the second to last stanza of her pantoum. How do you finish a pantoum? When I come to this question I am often reminded of my cousin Margy, whom my sisters and I adored. She taught us all how to knit, long bulky scarves out of purple yarn. The problem was, we didn't see her that frequently, and she never taught us how to cast off. As a result, we created endless scarves that could never be worn. You don't want that to happen with your pantoum. Luckily, there are neat ways to end it.

Joan Logghe's last stanza uses the most common grid for the pantoum in English:

_____(Repeton from line 2 of previous stanza)
_____(Line 1 of the opening stanza of the pantoum)
_____(Repeton from line 4 of previous stanza)
_____(Line 3 of the opening stanza of the pantoum)

This is what it looks like in the poem:

She's kissed a boy she loved and some she didn't.
The dark boy leans against his pickup truck.
I sat with older mothers who had moved on.
I say to myself, "Let go. It's not worth creating a tragedy."

Notice that here Logghe does vary the last line for emphasis. Another way to end the pantoum is one I like to use in my own—to flip lines 1 and 3 of the first stanza so that the poem ends with the same line it began with:

_____ (Repeton from line 2 of previous stanza)
_____ (Line 3 from the opening stanza)
_____ (Repeton from line 4 of previous stanza)
_____ (Line 1 from the opening stanza)

This gives the feeling of a complete circle.

Another example of the pantoum, used to create a lyric poem of conventional length, is Mary McGinnis's "Stop." The subject matter is that of a recurring dream, obsessive unconscious material that finds one of its best containers in the pantoum form:

I have this one dream over and over—
I'm in the back of the audience,
I have to get to the front—
I'm lost, walking through water.

I'm in the back of the audience;
I know the man on the stage—he doesn't make sense.
I'm lost, walking through water—
My ears are clogged up.

I know the man on the stage—he doesn't make sense.
Stroke. Heart attack. He gurgles.
My ears are clogged up.
They're shells without a voice. I don't want to hear him.

Stroke. Heart attack. He gurgles.
He has forgotten his lines. I prompt him. *Tell them your name.*
They're shells without a voice. I don't want to hear him.
Stop, I yell. This hurts.

He has forgotten his lines. I prompt him. *Tell them your name.*
This could be my father, my lover, my best friend;
Stop, I yell. This hurts.
I choke, I sob, I stumble down the aisle.

This could be my father, my lover, my best friend.
I have this one dream over and over—
I choke, I sob, I stumble down the aisle—
I have to get to the front.

It should be obvious to you by now—and certainly will be once you start experimenting with writing the pantoum, that there is no way to control it. You have to trust that the form itself will give the poem its sense, and to allow for happy accidents and juxtapositions. To further complicate matters, it is possible to rhyme the pantoum. The rhyme scheme for the pantoum is abab, bcbc: that is, lines 1 and 3 rhyme, as do lines 2 and 4. However, keep this strictly optional. The pantoum is complex enough not to need rhyme—but do try a bit of partial rhyming or half rhyme if it appeals to you. I also sometimes use the pantoum as a temporary stage in writing a poem. I might put a poem into a pantoum to see the effect, then break it out in the next draft into looser quatrains. Try this as a way to add just the echo of structure in a poem, and as a way to free up its leaps and associations.

The pantoum seems particularly suited to us writing in America at the end of the twentieth century. Its repetition and circular quality give it a mystical chant-like feeling. Its cut-up lines break down linear thought. The form is both ancient and fresh. Once you embark on it, it will be a poetic path you will want to take again and again.

CHAPTER 8: THE VILLANELLE

The Virtues of Repetition

The repeated forms of poetry, such as the pantoum and the villanelle, are based on refrains. This repetition of lines does some of the work for the poet—you don't have to invent something new every minute of the creation process. Repetition is also lulling, melodic, soothing—it is the adult equivalent of a lullaby. The villanelle and the pantoum were invented thousands of miles apart, by people from different cultures and language groups. Yet they share the virtues of repetition.

As a contemporary poet, you are no longer bound by borders—of nations, language, or the imagination. Poetry at the end of the twentieth century is essentially international; forms both ancient and modern are part of our repertoire. In my teaching, and in this book, I have tried to emphasize forms which will *work* for you. Some of the traditional European forms go splendidly with contemporary poetry—forms such as the ballad and the villanelle. But I have omitted the sonnet, for example. The many rules of the sonnet do not seem to liberate the poetic impulse for us today. If you feel drawn to the sonnet form, I would suggest you use it in a highly modified form. The sonnet is a fourteen-line poem. It usually divides into two sections, one of eight and one of six lines. It is written in iambic pentameter with a rhyme scheme that may vary but which often goes abab, cdcd, efef, gg. The one element of the sonnet that I like to use is the familiar shape of the fourteen lines. If you have a thirteen-line poem, add a line to see if that doesn't complete it. The same is true of trimming down from fifteen or sixteen lines. Our ears in English seem hardwired for those fourteen lines.

Add whatever other elements you like from the sonnet—sections, rhyme, meter—but use them loosely. The final effect may be a free verse poem with a crisp shape.

Between the Lines

Unlike the sonnet, however, the villanelle will usually produce a highly successful poem in English. The English language and its poetic forms have always been tremendously malleable and open to innovation. As poets writing in English we can be grateful that our language picks up vocabulary words from so many sources—from French to Spanish to Yiddish to Japanese—and that poetic forms come to us from Asia, Europe, and many oral traditions. The same is true of the culture around us. You might eat knishes and sushi in the same day, wear Guatemalan fabric while driving a Japanese car, listen to African music influenced by African-American music, and still pray the words of an ancient prayer or make soup the way your grandmother did. This mixing of tradition and innovation is at the heart of where poetry is going—and we should enjoy it because this is a unique time in the world, and in writing.

The villanelle came into English in the seventeenth-century from its original form as an Italian folk song and dance. It passed through France, where the literary form was standardized. It has an oral root, like the ballad and pantoum. The villanelle is based on a series of refrains and rhymes; and its lines may be of any length. However, it is easiest to handle a villanelle whose lines are about ten syllables long, or a bit shorter. The grid for the villanelle is as follows. Notice that for writing one, you need two truly excellent lines, which function as the refrains A1 and A2:

_____ Line 1. A1 Refrain.
_____ Line 2. Free line. Rhyme B.
_____ Line 3. A2 Refrain.

_____ Line 4. Free line. Rhyme A.
_____ Line 5. Free line. Rhyme B.
_____ Line 6. A1 Refrain.

_____ Line 7. Free line. Rhyme A.
_____ Line 8. Free line. Rhyme B.
_____ Line 9. A2 Refrain.

_____ Line 10. Free line. Rhyme A.
_____ Line 11. Free line. Rhyme B.
_____ Line 12. A1 Refrain.

_____ Line 13. Free line. Rhyme A.
_____ Line 14. Free line. Rhyme B.
_____ Line 15. A2 Refrain.

_____ Line 16. Free line. Rhyme A.
_____ Line 17. Free line. Rhyme B.
_____ Line 18. A1 Refrain.
_____ Line 19. A2 Refrain.

As you can see from the grid, the villanelle relies for its effect on a double sort of repetition. The two refrains are repeated, first as a rhyme in a tercet, then as alternating refrains, and finally coming together in a rhyming couplet. The refrains are joined through sound, meaning, and through a pattern that separates them and then draws them together in a kind of conclusion. Each stanza or three-lined tercet also makes a kind of rhyme sandwich—with Rhyme A functioning as the two slices of bread and Rhyme B functioning as the filling. Because the refrains are also Rhyme A this is the sound that will dominate, making Rhyme B more of a sub-

theme or leitmotif in the poem. As an example, here is a villanelle I wrote.

Villanelle

Junkies on Baca Street sit in the shade
Only cross the street to score
Purple iris blossoms unafraid

Vein is what a needle can't evade
Shadow by definition is obscure
Junkies on Baca Street sit in the shade

Blue chicory beside a broken spade
The steps are crumbling by the door
Purple iris blossoms unafraid

No women here, although the bed's unmade
Purple-hearted plate is from the war
Junkies on Baca Street sit in the shade

Rice and beans have been delayed
The pan is burnt, the arm is sore
Purple iris blossoms unafraid

Death, I've called collect, you gave
Poverty, what life gives more?
Junkies on Baca Street sit in the shade
Purple iris blossoms unafraid.

For me, the two refrains have a contrasting quality. The first, with the junkies, is harsh and realistic while the second is a more serene image from nature. Once I had the refrains in place I let the creative process of the villanelle itself take over, simply touching on those details I saw and placing them into the form. The subject was dictated by the refrains, but the filling on the sandwich lines often came as happy accidents as I followed the scheme. Indeed, these junkies

who lived right around the corner often haunted me, and I wanted to get them into a poem. The formal constraints took me deeper into the subject, particularly where it touches on death.

Notice too when you start to work with the villanelle form that it flows for five stanzas in the tercet form. Those three-liners have a spacious free-floating quality that resolves in the sturdier quatrain that concludes the poem. Don't feel that you must *say something* important philosophically with the villanelle—that isn't necessary. But the form does have a built-in conclusion and sense of resolve.

Once you have followed the path of the villanelle you should have learned a great deal about repetition, rhyme, and refrain. My suggestion would be to write at least three to five villanelles when you are starting out. Work as fast and spontaneously as possible, just hacking out those refrains and intermediate lines. Part of the process here is to over-write. You may find you like part of one villanelle, and then cut and paste it with another.

The villanelle in its original song form was pastoral in nature—that is, its subject was nature and love. Your villanelle probably won't be about shepherds and shepherdesses gamboling on the green, but adding some nature may strengthen the poem. I found the iris image helpful for that reason in mine. Among the most famous villanelles is Dylan Thomas's "Do Not Go Gentle into That Good Night." The title is Refrain A1, matched with A2: "Rage, rage against the dying of the light." Theodore Roethke's "The Waking" is also a beautiful example. These two examples serve as a kind of touchstone for the modern villanelle—Thomas's is about death, Roethke's about perception and an altered state. The

villanelle is also a good place to give a direct command, advice, to gently boss the reader around. Tell us to do or believe or see something in a villanelle. These are just some suggestions based on the traditional usage of the form. Ultimately, let the villanelle itself be your guide. Eventually, your own thoughts and images will come together intimately with the form—and you will have your villanelle.

CHAPTER 9: THE SESTINA

Narrative in Poetry

I once gave a poetry reading in the middle of a snow-storm in Taos. The drive up from Santa Fe was slow and arduous, as the storm obscured my vision and the highway turned and twisted between the river gorge and a cliff face of red rock. I was relieved to finally spot the place I was to read—a tiny restaurant appropriately named The End of the World Cafe. It sat on the highway by the hamlet of Ranchos de Taos, right next to the large adobe church made famous by Georgia O'Keeffe, who painted its smooth organic walls and buttresses. Inside, the cafe was warm and steamy and smelled of vegetable soup and coffee. A dozen brave poetry-loving souls comprised the audience. The two poetry readers were myself and Alvaro Cardona-Hine, a poet I had long admired. Alvaro had been born in Costa Rica, spent years in Minneapolis, and eventually moved to the tiny town of Truchas in the hilly country behind Taos, known as the High Road. I thought of him as a master of the short lumi-nous poem, influenced by Japanese forms.

We enjoyed reading, and the audience was responsive. Afterward, Alvaro took me aside for a moment and gave me an apparently off-the-cuff piece of advice that was to haunt me for years. "Don't be afraid of the narrative in your poetry," he said. Here was a poet I admired, more of my parents' gen-eration than mine, who in those days sported a dark beard and a black felt hat. I knew I should take whatever advice he proffered, but what exactly did that mean—don't be afraid of the narrative?

Every poetic form has tension built in—a tension between its constraints and the urge for free expression. I've always felt that the lyric poem should paint a picture, and I've written fiction to tell stories. But stories kept creeping into my poems—partial, complete, myth, memory—stories wanted in. After that encounter with Alvaro at the End of the World Cafe in the snow, I stopped trying to force story out of my poems. Stories after all are gossip—or gospel—one of our greatest sources of what it means to be a human being.

The Six Gates

Paradoxically, the repeated poetic forms—which are the most melodic—also have a tremendous potential for narrative. The ballad is perfect for telling a long story. The pantoum works with autobiographical obsession. And the sestina, perhaps the most complex form, also works to create a narrative of its own.

The sestina is a scary form—tantalizing if terrifying. What makes it difficult to write is that it depends upon words, rather than lines, for its effect. It works through the patterned repetition of six words in an extremely formal grid. It has six stanzas of six lines and one stanza of three. This highly limits it. The sestina's magic number is six—while the ballad's is four and the villanelle's are three and four. While the use of individual words restricts it, the use of six whole repeated factors expands it. This makes the sestina exciting to write and read. To write a sestina, you must pick six individual words. We will refer to them as A, B, C, D, E, and F. Each line of the stanza ends with one of these unrhyming words in the following pattern:

 A
 B
 C

_____D

_____E

_____F

_____F

_____A

_____E

_____B

_____D

_____C

_____C

_____F

_____D

_____A

_____B

_____E

_____E

_____C

_____B

_____F

_____A

_____D

_____D

_____E

_____A

_____C

_____F

_____B

_____B

_____D

_____F

_____E

_____C

_____A

_____A_____B

_____C_____D

_____E_____F

Note that in the final stanza, or tercet, the six words are all strung together in the same order that the originally appeared in in the first stanza, in a kind of pile up in bumper to bumper traffic.

An actual sestina should make the form even clearer. In the following sestina, "Snow Ghosts" by poet Joanne Young, the six repeated words are "bodies," "snow," "water," "ghosts, "AIDS," and "rising." All are fairly mundane words, except for AIDS, which is highly saturated with emotion and association. Five are nouns, while one is a verb form. Here is what Young does with them:

Snow Ghosts

Black in the night of wordless bodies,
Silver-blue sky of snow,
Yellow wheat stalks poke through frozen water.
In between lies a world of ghosts,
Lepers, holy man, and people infected with AIDS.
You can see the smoke rising.

No hope for the spring peppergrass rising.
Tattoo the black octopus sucking tendriled bodies.
Shot into fertile soil, the seeds of AIDS
Burrows deeper into dark snow.
Roots become the food of ghosts,
Acid is falling rainwater.

Floating facedown in the water,
Currents pulling, the tide rising,
Clouds hover closely in the shapes of ghosts.
Bleached warriors shed skin from translucent bodies,
Outside the hospital window drops snow,
Inside the four walls you die of AIDS.

Babies strapped in cribs scream the cry of AIDS,
Long for the touch of their mother's hands, water
Bathing them warm after the chill of snow.
Steam and powdered scent of purity rising.
Souls beg for escape from diseased bodies,
Halos of thorn adorn the tiny ghosts.

They say if you linger between the worlds, you become a ghost.
Left on the bedside table, a bottle of AZT.
Individual graves for individual bodies,
They took his head, St. John of the water,
Flamed thirst of anger rising,
Quenched in the blue light of softly falling snow.

Small white owls hatch from eggs as white as snow.
Hungry Lakota danced the dance of ghosts
In hope of buffalo and ancestors rising.
Can they find in the tears the virus of AIDS?
Sponging your withered arms and legs in the water
You asked me to hold your head down and drown your body.

209 bodies and Bigfoot lay frozen in the snow,
freed in the spring water, ghosts return to haunt.
Charcoal kisses lend aid to the rising heat.

In her sestina, Joanne Young weaves a loose web of images and narrative. The theme is of suffering and death, a desire for safety and redemption. Bits of stories appear and disappear, merge into each other, fade as dreams. She isn't using the sestina to tell a strict story, but in Alvaro Cardona-Hine's words, she isn't afraid of the narrative, either. Most interesting from a technical viewpoint is her use of the words "AIDS" which transmutes at one point into the medicine for the disease itself—AZT—and then at the end into the more hopeful "aid." Another thing to note about the sestina form is that by necessity it lends itself to odd line enjambments, or line breaks. Line breaks are usually dictated by the need

for rhyme or meter, or syllabic count, or even just where the poet wants to indicate to the reader to pause for a moment of breath. This obviously cannot be the case with the sestina, where straining for sense can cause the line to break in the middle of a thought or breath. Some poets use extremely long lines to try and counteract this problem inherent in the sestina form. You can use the sestina to further explore line breaks, and to allow yourself some freedom to cut them in unusual places.

Through the Revolving Door

About a half mile from my house is a huge warehouse that functions as a museum of contemporary art called Site Santa Fe. It recently housed an exhibit by Willie Cole, "The Elegba Principle," which consisted of a series of actual wooden doors set up to revolve if pushed. Each door had a word boldly printed on it. Poet Judyth Hill led a poetry workshop in the site, where she brilliantly assigned the sestina based on six words—or six doors—of each writer's choosing out of the exhibit. Judyth Hill's assignment concretized or literalized the sestina. Each of the six words in the sestina is a door you *go through*—for meaning, sense, and perception.

Local poet Yehudis Fishman choose the following six doors: coffee, sugar, freedom, denial, believe, poverty. These are mostly nouns, the first two words are concrete and the next four somewhat abstract. She used them to weave a sestina that is both autobiographical and philosophical:

Hindsight

A psychic saw my mother forgive me when I brought her
 morning coffee—
I don't remember if she used to ask me for sugar.
When she died I felt a guilty glow of golden freedom—
When my father died I slipped into a robe of dull denial.

About an after life, I've no idea what I believe—
But my heart insists that on the other side there is no poverty.

Before I met my best-dressed classmates, I didn't know that poverty
could cause such sadness—that only a few cups of coffee
could make my eyes glow with what I believe
was an answer to an emptiness filled only by sugar.
My mother came from Europe in a crowded ship called Denial,
and overboard threw kosher food—her offering to freedom.

Did she know in 1929 that soon there'd be no freedom
for six million who would have given all away to live in poverty?
While the civilized world turned its skeptical head in denial,
calmly sipping its tea and gulping down its saccharine coffee,
six million wallowed in blood without any sugar—
and dancing beyond reason, some still sang the song, 'I believe'.

In Contact, Jody Foster insisted she could not believe
in a G-d without proof—she could not let go of freedom
to live without peace of mind that tastes just like a strange kind
 of sugar.
Said her friend, 'let's spend those trillions not on planets but on
 poverty.'
All night the folks at ground control stayed up by downing black
 coffee,
while mesmerized aliens followed the dance of faith and denial.

At ten I stole comic books and told myself in a fog of denial,
G-d needs to reward me because I still can believe
that my mother deserved for her pain, that one cup of coffee
where I could still toast her brave flight to freedom—
the flight that gave birth to my singular chance to live in poverty
and flee from the blood of six million to a spoonful of sugar.

Now I remember—she did ask me to put in some sugar;
It was her way of avoiding the bitter taste of denial—
it was her way of finding an afterlife to poverty.
If I told her now about the comic books, I believe
she'd smile, and whisper. 'I told you there's two sides to freedom,'
and I'd smile back and carefully pour her sweet strong coffee.

In a tenement without sugar, my mother spooned out 'I believe',
In a hospital bed of denial, my father slipped out into freedom.
As for me—I can see—there's no room for poverty in a fresh
 cup of coffee.

My favorite line in the sestina is "My mother came from
Europe in a crowded ship called Denial." That is one of the
beauties of the form—I suspect the poet could never have
found such a line without following the constraints of the
sestina. As you yourself set out to write one, note how the
repeated words form a kind of split couplet between the
last line of a stanza and the first line of the next. There is
poetic satisfaction in this repetition—it is musical and also
allows for shifts in grammar, puns, and changes in meaning
as the sestina spins along. In Yehudis Fishman's sestina the
tercet, or envoy, is handled differently than in Joanne
Young's. This variation is the other classical ending of the
sestina, where the words run in a pattern of BE/DC/FA or, in
this case, "sugar," "believe," "denial," "freedom," "poverty,"
and "coffee."

You can end your sestina with either form of the tercet—
and the truth is, many poets just invent their own envoy,
running the words in whatever order suits them. Whatever
you do, don't miss the opportunity to naturally sum up or
conclude the themes of the poem. Apparently the French
troubadours, the wandering Medieval poets who popularized
the sestina, attributed a mystical theory of numerology to
the form and its pattern of repetition. That exact meaning is
lost to us today, but the sestina does retain a mysterious
and powerful quality because of its form.

Pick a Card

For many years I've used a wonderful aid to the writing of
poetry—a pack of poetry cards. All you need to make your

own is fifty index cards. First, generate a long list of words that appeal to you. Don't do this all at once; take a few days or even a few weeks to write your list. Put down ordinary words you like, but be careful not to use just nouns and adjectives—in particular, add some verbs. Then put down a few exotic words you are fond of, like "caliche" for mud or "faience" for blue pottery glaze. Keep collecting. At the end, add a few oddities—the name of a state or country, a person, a street address. Once you have a list of over a hundred words, prune it down to exactly a hundred.

Now get out your cards. Treat each as if it was a playing card by writing one word on the top of the card, then turning it upside down and writing a second word on the new top. The words should have no relationship to each other. What you will have is a word equivalent to say the Queen of Hearts—it can be read from either side. Put two words on each card until you have a deck of fifty. These cards will be incredibly handy for inspiring poetry. If you don't know how to start—pull a word, or three or four. Use those words to start writing. For a sestina, of course, pick six words and spread them out. Or invent your own form using the deck. When you get tired of certain word cards, replace them with new words. With this deck of cards sitting in your writing space you won't ever feel that you can't get started.

CHAPTER 10: THE SHORT FORMS

War and Language

The look of American poetry in the twenty-first century is international. In part, this is because English is among the most malleable of languages. In 1066, the Normans invaded England, conquered and ruled it. This conquest by the French effectively broke the backbone of Old English grammar, which was Germanic in origin. Thousands of French words—in every area from gardening to philosophy—entered the English language, and stayed there. Before that, Vikings had come in their long dragon boats, raiding the island and bringing in words like "shoot." Because of a history of invasion, English has been particularly open to the influence of other languages.

In the United States, immigration changed English. Linguists studying the way the average New Yorker speaks note that the grammar of Manhattan takes some of its structure from Yiddish and Spanish. English is an enjoyable language—not just the language of Shakespeare but of my grandmother, who as a non-native speaker amused us by referring to our "friend boys" instead of our boyfriends. English poetry has been as receptive as the language. In the Middle Ages and Renaissance poetic forms came into English mostly from the Italian and French. This was the path of the sonnet, the villanelle, the sestina. In the last hundred or so years the forms that have come into English are not European, but rather from Asia, the Middle East, the Pacific, and from indigenous Native cultures worldwide. Some of this is the influence of immigration, much of it from war and occupation. And to me, a lot of it is a positive wave of the future—where

the music, poetry, food, and fashion of the world mix with each other in an unprecedented cultural meeting.

As a group, the Japanese short forms have probably had the greatest influence on contemporary American poetry. Interest in Japanese poetry, with its clear simple images, began at least a hundred years ago. The Americans who tried to imitate this painting of an image in words included Amy Lowell, Ezra Pound, and H.D., who called themselves Imagists. But it was really after the Second World War that translators and scholars brought the haiku and other short forms to the poetic community of the United States.

Haiku

Because of the fad for teaching haiku to school children, this form may already be familiar to you. It is amusing—if a bit worrisome—that a complex compressed form is taught as something easy. However for poets—children or adults— the form is a rewarding one. The basic form of haiku is simple: three lines that total seventeen syllables or less. This seems clear, until you realize that in Japanese the "syllables" are really sounds written in characters and that the lines are written from top to bottom. But with an emphasis on brevity, which follows the Japanese, the form will work. Here is the grid:

 _____Line 1. 5 or less syllables.
 _____Line 2. 7 or less syllables.
 _____Line 3. 5 or less syllables.

The "or less" is a crucial way of vitalizing the form. This gives it an uneven feel, much less plodding than the traditional way of producing a rigid 5-7-5 haiku in English.

The rules of haiku extend beyond the form. In fact, the rules are so numerous that you could make a lifetime study of them. Japan is full of haiku clubs where poets write and compete, and in the United States haiku has sometimes been limited to poets who wrote only haiku and who had a kind of hobbyist's enthusiasm for the form. But what you want is to develop as a poet, not to be the equivalent of a garden club member myopically focused on growing the perfect roses. So how can the haiku work for you?

The rules that are the most useful for us include the following. Haiku should be about pure observation, without metaphor. It focuses on nature and daily life. There is no rhyme or repetition in the poem. Instead, it gives one vivid image. There is also usually a contrast in each haiku, either explicit, or implied. I find it easiest to break the sense of the haiku between lines 2 and 3—to put the contrast there. One final rule—many haiku are grounded in a specific season. It is usual to put in a seasonal reference—this can be as simple as snow or as complicated as taking your clothes to Goodwill, which implies spring cleaning. I once asked a group of sixth graders to give me a spring seasonal word and they— New Mexicans in mud season—said "four-wheel drive vehicle." If there is no seasonal reference, be aware of it—this should not be by accident but on purpose. Also, haiku is usually not written in full sentences or even in what we would consider full lines, but rather in phrases or fragments. All this points to the sensibility of haiku—a brief record of a changing, fleeting word. I once heard a Zen teacher lecture about the difference between plastic or silk flowers and real flowers. Real flowers fade and die, their petals fall. That is actually what makes them more beautiful. A look into the transitory nature of things—and therefore a look into beauty—is the essence of haiku.

There are four haiku masters in Japanese: Basho, Issa, Buson, and Shiki. Many fine translations are available of their work—read as many as you can get your hands on. Basho is probably the most beloved by American haiku poets. One of his haiku, which is limited to the elements of an old pond and the sound of a frog jumping in, has been translated so many times that there is a whole book of different versions. You can use this, or any traditional haiku, as a kind of meditation aid. Say it over and over like a mantra, stare at it as you would a candle or a mirror. What do you find? What is the image? The contrast? The feeling tone? The season?

When I first moved to Santa Fe, I sent a change of address card to the editor of a haiku magazine, Frogpond's Elizabeth Searle Lamb. She wrote me back, saying we would be neighbors, and invited me to tea. I drove my old clunky Dodge Aspen up the winding street that ran along the Acequia Madre, an ancient central irrigation ditch. Even though it was only early winter, an unseasonable mountain snow storm had blanketed the city. Every adobe wall was outlined in white. Frustrated by a series of one-way street signs, I finally ditched the car and walked the rest of the way. I was greeted by a lovely looking white-haired woman, who fed me tea and cookies. Elizabeth Lamb became my informal mentor in the craft of haiku.

She might have written the following on the day I first visited her:

> a branch of pine
> sways with the weight of raven
> and the falling snow.

Then on to spring:

> lilacs in bloom
> but no one now to decorate
> the family graves

In summer:

> summer sky
> and the slow drifting
> of one cloud

Then autumn:

> ancient cottonwoods
> drop their leaves in the acequia
> September's brittle wind

Lamb's haiku exemplify brevity, a sense of the moment, the poignancy of time passing. They are also deeply rooted in place. Use the haiku form to help you to wake up to where you are. Rain in Manhattan is different than rain in the pueblo of Zuni; signs of spring in New Zealand are different than those on Cape Cod. Haiku is now international, not just Japanese in its expression of place and culture. But the ancient form is an antidote to the not seeing, not noticing, not feeling of the busy contemporary world.

The Senryu

The senryu is essentially just a haiku with a twist—of humor, of eroticism, of the human world. It is a subcatagory of haiku, with exactly the same formal structure; its subject material, however, is looser. The Japanese poet Issa has some great senryu about being bitten by bugs. So does Albuquerque poet John Brandi:

Driven
from one inn to another
by no see ems!

Brandi's work captures much of the feeling of traditional senryu. Here are a few:

Between his father's snore
he hears each wave
cover the beach

Searching for the key
there in my pocket
all the time

A job interview:
the principal's chair
higher than mine

Brandi's poems are tiny slices of life. Use them as an inspiration for observing yourself and others.

Continuing Along the Way

A good way to practice with senryu and haiku is to get a special—small—notebook and carry it around in your backpack or purse or briefcase. Get one of those handy ones about two by three inches and take it everywhere. Try writing at least half a dozen haiku/senryu a day. Observe the weather, the season, the human scene. Have a brown bag lunch in a park and watch what goes on around you. Write it down in three-line poems. Later on, toss out the ones that don't work. Still, you should be pleasantly surprised by how much you have written. Haiku or senryu sequences are a good coping device for continuing to write under extreme circumstances. If you are in the midst of pregnancy and

childbirth, ill in bed, caring for someone who is dying, probably writing poetry is not high on your to-do list. But to stay alive as a poet, you must write. The Japanese poet Shiki wrote exquisite haiku when bedridden with tuberculosis of the spine. The Japanese tradition is that haiku masters should write a poem on their deathbeds. This is in part because haiku is a spiritual practice of concentrating on the moment. Don't be too intimidated, though; many worried poets composed multitudes of death poems when they were in good health, no doubt planning to whip them out later at the last moment—just because of the fear induced by performance anxiety!

You don't have to write on your death bed, but you should try to under most other circumstances. One great method of writing haiku is to break into the form when you are keeping your usual diary or journal. In Japanese, a mix of prose and haiku is called a haibun. It is a great way to write while traveling, or to record any intense experience.

The quintessentially American poet William Carlos Williams was a doctor in Paterson, New Jersey. In between patients, he wrote poems—short ones—on his prescription pad. The poems were short both because of the briefness of time he had and I imagine also because the pad was small. Williams gave in to his circumstances and even let his environment dictate poetic form. His other gift was concentration, the ability to observe and live experience, then compress it into words. Williams made little distinction between the stream of life and the stream of poetry. To me he is a kind of guardian saint of poetry. If I must take my daughter to school, wait for the plumber, go teach college, pay bills, and answer the phone I invoke the spirit of William Carlos Williams to help me concentrate on the short form.

Another useful example from the Japanese is the tanka, which simply means short poem. The tanka is basically like a haiku, with two lines added. For this reason, there is often a break in sense between line three and line four. Here's the grid:

> _____5 syllables or less
> _____7 syllables or less
> _____5 syllables or less
> _____7 syllables or less
> _____7 syllables or less

Tanka are looser than haiku, and are often emotional pictures, moody looks at love or the passage of time. You can use the tanka the way Williams used his short syllabic poems; again, try to write more than one a day—whether on your legal pad or shopping list.

The Renga

It is fascinating to note that the ultra-short form, the haiku, actually derives historically from a long collaborative poem called the renga or renku. This is an extremely complicated Japanese form, but I love it because it can be written in a group, by two people, or alone. It is impossible to include all the rules here, which for some take a lifetime of study. Rather I have emphasized those which will make good poems in English.

Renga were traditionally written in small groups, or parties, with lots of eating and drinking as well as poetry writing. The form began about a thousand years ago, and grew out of tanka competitions in Japan. Here's how it goes. The first poet writes a three-line poem called a hokku. It is the same form as a haiku. In fact, the haiku comes from it. Imagine a

bunch of poets all trying to write a hokku starting verse. Only one hokku gets picked to start the renga, and poets of course don't like to throw their work away. So every poet would have some excess poems. These three-liners eventually were just written on their own, and become the haiku.

The next poet must "cap" or follow the first three-line stanza with a two-liner. The couplet, like the end of the tanka, is of two lines each with seven syllables or less. The renga does indeed look like a chain of split tankas:

> _____5 syllables or less
> _____7 syllables or less
> _____5 syllables or less
>
> _____7 syllables or less
> _____7 syllables or less
>
> _____5 syllables or less
> _____7 syllables or less
> _____5 syllables or less
>
> _____7 syllables or less
> _____7 syllables or less

And so on, repeating in this pattern for a total of 36 stanzas, ending on a couplet. Some of the basic rules of the renga include starting with a hokku that sets the season and place. Try to continue for about eight to ten stanzas concentrating on haiku-like perceptions of the world. As you mention the seasons, go forward in time. You can skip a season, and use non-season verses, but don't go backwards. Towards the middle of the renga, the poem heats up. Subject matter is wide open, with a senryu feel. Traditionally, there are three erotic verses here, dealing with love. I imagine that as the renga poets ate—and drank—the renga got looser and

wilder. The most difficult rule of the renga is that no repetition is allowed. In strict ones, that means if you mention an ant, you can't mention a grasshopper—as both are insects. You might be looser than that, but don't use the word rain or snow more than once, or repeat an image. The renga has forward motion; it is literally like a chain. As you add each link, concentrate both on how it is like—and how different from—the verse before it.

Poetry Party

If you can, gather a small group of friends and poets. Serve some snacks and drinks. Have everyone try and write a hokku, or opening verse, and pick the one that feels best. Then do the same for the following couplet, and so on. I once worked with a group of Japanese renga poets who depended on the decision of their master, or sensei, for each link. You can choose a leader, or work collectively. It will take a few hours to write a renga in a group. Or consider just writing half—at 18 verses.

Renga can also of course be written by mail, where one person starts off and sends it to the next. If you work with four or five poets this way the result can be very fresh and spontaneous. E-mail is becoming an irresistible medium for renga. Two poets can write a renga as well, switching back and forth. Elizabeth Lamb and I have done several renga this way, sending it in the mail. Although we live just a few miles apart, we both love getting mail and this system has worked for us. On hectic days I have felt a sense of accomplishment just writing one link and sending it back to her. Make sure to double up verses occasionally, so each poet has a chance at both the three and two liners. And in all cases, mark each

link with the name or initials of the person who wrote it. Here is the opening of a renga I wrote with Elizabeth:

> Georgia O'Keeffe
> a splash of brilliant sunset ESL
> across the cliffs

> fossil shell
> in my daughter's palm MS

> pale hollyhocks
> by the weathered gate ESL
> a butterfly

And from the middle of the poem:

> a hacking cough
> in the silence MS
> of the election booth

> the phone stops ringing
> just as I reach it ESL

And the poem ends, as many renga traditionally do, with an image of spring:

> a patch of old snow
> lingers into spring ESL

> but what about
> those yellow crocuses MS
> we saw together?

> the new lambs frolic
> in the south meadow ESL

You can also write a renga by yourself, although this removes the collaborative element. Write one as you would a series of haiku, pausing in between links. Again, it is a good form to record a journey, or to serve as a diary.

The haiku serves as a spiritual wake-up call in poetry. It derives from the long loop of the renga, one of the only collaborative poetic forms in existence. The renga is a practice of letting go of your own work to serve the whole. Despite its rules, it is as spontaneous and uncontrollable as the pantoum. When you write renga, don't throw anything away. You will find many haiku, senryu, even tanka in the links that don't make their way into the finished product.

CHAPTER 11: THE ELEGY

Are You Experienced?

I spent a large part of my adolescence and young adulthood waiting for something exciting to happen to me so that I could write about it. As a teenager I was driven crazy by the seemingly bland inertia of my family's large white house on a suburban block. It was not until I was much older that I was able to write about—and admit—the things that had gone on on our block, ranging from incest to addiction to suicide. There was enough excitement there to stock a Greek tragedy, but it wasn't obvious to me.

Other memories from 153 Dwight Place would also play an important part in my writing. Perhaps the most important was my Russian Jewish grandfather Avrum, who came to live with us when I was ten and died when I was thirteen. Covered in scars from the adventures of his youth and the surgeries of his old age, he was a fascinating link to the long gone world of the shtetles of the Pale, Socialist Revolution, Russia, Asia.

But as a teenager I was ravenous for more violent experience. I spent hours in my bedroom with the lights out, dancing around to Bob Dylan and Jimi Hendrix. Their lyrics seemed to accuse me—I was going nowhere. Interestingly, I recently discovered that I was not alone in my perceptions. As I was revising this book, I was browsing through Tony Hoagland's poetry. Imagine my surprise to find the Hendrix line I'd lifted as a chapter subheading titling one of Hoagland's poems: "Are You Experienced?"

While Jimi Hendrix played "Purple Haze" onstage,
scaling his guitar like a black cat
up the high-voltage, psychedelic fence,

I was in the parking lot of the rock festival,
trying to get away from the noise and
looking for my car because

I wanted to have something familiar
to throw up next to. The haze I was in
was actually ultraviolet, the murky lavender

of the pills I had swallowed
several hundred years before,
pills that had answered so many of my questions

Here the yearning for experience actually backfires—the poet misses the performance of a lifetime because he is sick from the misguided teen-age habit of searching for enlightenment in a handful of chemicals. The experience is a claustrophobic one, not a liberating one, and maybe a symptom of what happens when a poet-in-the-making is searching for ways to broaden perception without the right tools. Note too that this bittersweet poem is written in triplets, those unstable three-liners that roll from stanza to stanza reflecting uncertainty and disorientation.

In my own search, I sniffed tear gas at anti-war demonstrations, had a lover, and tried to immerse myself in worlds of painting and books that would take me *out*—out anywhere beyond the confines of suburbia. Anne Sexton, the poet of the crazed nightmare of suburban vision, was just becoming famous at the time. I read her, but not with much interest— I had no intention of remaining trapped.

In my twenties, I dropped out of graduate school and ran off to San Francisco in its halcyon days just before the outbreak of the AIDS epidemic—perhaps the last Baby Boomer to do so. Experience came my way, both on purpose and as life would have it. I suffered a serious illness and surgery that left me with some chronic pain. My heart was broken— more than once. But I also threw myself into what California had to offer—from massage to Zen Buddhism. There on the edge of the continent I felt I was finally *out*.

But, interestingly, it was less extreme experience that led me to develop the most as a writer. I married my first husband Robert Winson, moved to Santa Fe when it was still a relatively quiet place, bought an old stucco house, had a child. These experiences were utterly unremarkable, but they touched me more deeply than what I had known before. I was happy to write about them. I wrote at least two poetry books about pregnancy, the birth of my daughter, and her babyhood. I began to realize that while experience is necessary for the writing of poetry it does not have to be a particular kind of experience. And so I led a fairly peaceful life, surrounded by the extraordinary beauty of northern New Mexico's mountains, rivers, and mesas, and enjoying my old-fashioned neighbors on Santa Fe's funky west side.

Then, everything changed. My husband Robert was diagnosed with ulcerative colitis. The disease, not usually considered fatal, was one of remissions and attacks. He had surgery, and made a partial recovery. Ten days later, his heart stopped. He went into a coma, and died.

Robert was thirty-six; I was forty-one. Something had happened to me, something dramatic and bad enough to qualify as one of those my-life-changed-completely essays at the back

of women's magazines, something that from a safe distance one would consider the perfect topic of poetry: lost love and death.

What happened instead was that I stopped writing. The experience of bereavement was very intense for me, perhaps because I had been very close to my husband. I had the usual difficulty—impossibility—with sleeping and eating, and for days I found it difficult to stand up for any period of time. I felt like socking the incompetent consolers who murmured that I could write about this. For the first time in my life, I did not care about poetry. And I certainly had no desire to write it.

This bizarre condition continued for several months. Day after day, reality seemed altered—too bright, too luminous, too disorienting, like a bad drug trip. I would hallucinate scenes of Robert's last hours while I was driving or trying to teach a class. Still, unpleasant as it was, my own state of mind fascinated me. It was as if I had never been this close to madness. The lack of writing fascinated me as well. For it wasn't lack of thinking about poetry—I would actually see lines of poetry in my mind's eye, floating across the inside of my forehead—complete and interesting lines. I just didn't have the strength or interest to write them down.

Two months after Robert died, I took my young daughter to visit my best friend Kath who was teaching English in Seoul, Korea. My travel agent and family debated the wisdom of going halfway around the world in Siberian cold to one of the world's ugliest cities, but I needed to be with my friend. As it turned out, I could not have chosen better. Not only did I get the companionship I needed, I was fascinated by Korea. From the women's communal baths to miles of

underground arcade selling silk flowers and rhinestone jewelry everything was new to me. I couldn't help but want to write. Seoul had the best stationary stores I had ever seen, tiny ones crammed between bakeries and drugstores, larger ones at subway stops, all selling notebooks of blue paper with stiff plastic covers, or kid's ones emblazoned with fuschia and lime green tigers, or cheap spirals covered in dragons wishing us Happy New Year. I started buying note-books. And I started scribbling down lines in them—lines about the neighbor kids building a snowman on the roof, my insomnia, how I missed Robert. Eventually, I even wrote a long poem about Robert's cremation. By the time I returned home two weeks later, I knew I would write.

Grief and Its Containers

Our society does not appear to know much about death. In a way we have been fortunate to have been spared the life experiences of even our grandparents—mothers dying in childbirth, children dying, a lack of antibiotics and vaccines that made life even eighty years ago a much more uncertain proposition. But the negative side is purely spiritual—we live as if death doesn't exist. I was a shocking, even frightening object lesson—a forty-one-year-old widow. A hundred years ago in the territory of New Mexico, or in the shtetles of the Russian Pale, however, my lot would have been much more ordinary. More traditional societies than ours deal with grief better than ours through ritual. I was immensely helped by the rituals surrounding Robert's death. Robert had been an ordained Zen Buddhist priest in the Japanese Soto lineage, and so his memorial service, cremation, and service marking the forty-ninth day after his death were done according to tradition. As a Jew, I sat shiva, and said Kaddish with a minyan of ten people who arrived at my house every after-noon for that purpose. The rituals surrounding death come

from an earlier—more ancient—time and serve to first of all acknowledge death and its attendant grief, and then to console, and eventually to move the mourner back into life. That last stage initially seemed impossible to me. I asked a Hassidic teacher why as a wife I was given only a thirty-day mourning period. Even the Buddhists only gave me forty-nine. The teacher told me that the mourning period was too short *on purpose*—its ending prematurely forced the mourner back into the everyday world.

The elegy, as a poetic form, partakes of the ancient ritual formulas around death. Its purpose, as a poem, is to remember the dead person, and to grieve. In this way, it is its own ritual, its own healing. In terms of contemporary poetry, the elegy depends upon *subject matter* and not upon form for its constraints. However, this was not originally the case. The word itself comes from the Greek *elegeia*, meaning a "song of mourning." Like many of the forms from the Greek, its origin is in song and dance, and it comes out of a physical experience, out of the body. A collection of short poems from Classical and Hellenic times, *The Greek Anthology*, (Loeb Classic) is full of elegies lamenting the shortness of life, those who died young, and even lost love. In the Greek, elegies were written in a specific measure. In English, this is approximated in a meter called elegiacs. Elegiacs are written in couplets, two line pairs. The first line is written in hexameter, which means it has six accented syllables. If you compare this to iambic pentameter you will see that it runs one foot, or accented syllable, longer. For English, this a very leisurely line, with a sense of spaciousness. The second line of elegiacs is pentameter, or five stressed syllables. However, since the Renaissance, elegies in English have tended to use any form the poet requires, rather than the classical one. The classical Greek meter, although interesting in the way the lines flow

and vary, is not that useful when translated exactly into English. However, if it appeals to you, you might consider writing a short elegy using the traditional couplet form. You'll find that the varying stresses create a very muscular, active line, and that there is a good echoing sound at the end. A looser way to do this is to just use a fluid hexameter and pentameter. In any case, it makes a good experiment with meter and may help you tap into the roots of the elegy form.

Words of Condolence

The elegy in English, however, depends mostly for its effect on its handling of the subject matter. By definition, the elegy mourns the loss of someone—a person, a place, even an idea or part of the self. An elegy may also take on the general idea of death. If you are writing an elegy about a specific person, keep the following in mind as you go. If you hit these traditional bases you will create a moving piece, and perhaps even feel better yourself. The structure of the elegy is not unlike the structure of grief itself. It opens with a direct acknowledgment of the death of the person. Indeed, you can think of the elegy as a kind of condolence call. Just as a condoler should never enter a house of mourning by making a joke or a remark about the weather, the poet needs to acknowledge the reality of the situation. The elegy them moves on to praise the deceased. Again, this is perhaps the most consoling thing a mourner can hear. A mourner wants to remember, to speak the dead person's name aloud. There may be taboos in some societies against this—and in our society it is surprising how other people don't want to "upset" or "remind" the bereaved. However, in the elegy, go for it—remember the deceased, praise him or her, even tell a sweet or funny story in remembrance.

The elegy then moves into lamenting, or grieving, what is lost. For many poets, this is the heart of the elegy. *Lamentations* in the Hebrew Bible is a long poem that grieves the destruction of the Jewish Temple, an overwhelming national and spiritual loss. An elegy can have a social or political core. Pablo Neruda"s "Spain in Our Hearts" grieves the Spanish Civil War. Lamenting out loud at a death is a part of many cultures, particularly Mediterranean ones, but is frowned upon in ours. The tearing of clothes, shrieking aloud, and wailing—whether heartfelt or simply formulaic—can be standard mourning practice. In the ancient world, and in some parts of the world today, the role and obligation of this kind of lamenting falls to women. However, poets of both sexes can take on the communal task of lamentation.

In the elegy form, part of lamentation is often the poetic trope that "nature mourns." The eighteenth and nineteenth-century British poets did this in a literal and picturesque fashion—with nymphs weeping, distressed rivers leaving their banks, leaves dropping from trees. This does not have to be done in an overblown manner. If you have ever had the experience of severe grief or loss, and then noticed ironically what a lovely sunny day it is, you can understand the impulse to make nature mourn. Even in a rhythm and blues ballad the singer might wish for rain to hide the tears of a broken heart. In the elegy, find your own way to have the outer world express the inner. This kind of metaphorical thinking will only strengthen your practice of poetry.

There is an interesting link between the elegy and the poetry of nature—called the pastoral. A pastoral poem is set in the country, in Elizabethan times it was usually full of shepherds and shepherdesses gamboling about. Note that there aren't any pastoral poems about the beauties and

innocence of nature before cities—a New Yorker might like to write one on a weekend trip while a hard scrabble farmer in Idaho or Vermont is less likely to find this authentic subject matter. Traditionally, the pastoral elegy combines the two forms, but there is a deeper connection. In nature we see both birth and death all around us—beautiful, unavoidable, inevitable. The golden leaves of autumn are literally dying, the cherry blossoms are more beautiful for being perishable. The cycles of the seasons and of vegetation are more soothing than upsetting to us—we can more readily accept death in nature than we can in ourselves, although of course we are also part of nature's cycle. The pastoral element in the elegy helps move towards healing. Of course, like grief, the elegy may also contain anger and a philosophical outrage or questioning about the meaning of death. Still, its ultimate movement is towards a more peaceful place.

Healing is indeed the final section of an elegy. It is here that the poet—and the reader—can come to some philosophical or emotional acceptance. You don't want to rush this in the poem, or in life, but it does give the elegy a sense of redemption. The much touted stages of grief are, in my opinion, vastly overrated. Grief is not a smooth progression from nasty emotions such as anger to "better" ones such as acceptance. Allow the elegy some ambiguity, but don't be afraid to also let it resolve.

Liminality

When I was in graduate school I heard the critic Helen Vendler take apart Milton's elegy "Lycidas." All the expected parts were there, but then Mrs. Vendler caught my interest by saying: "Every elegy should have a corpse." By this she meant a literal dead body—not an idea, but something physical. A corpse is an uneasy, frightening thing. It is both

the person and not the person. So why put a corpse in your elegy? First of all, it is a kind of reality check. One woman I know who was abruptly widowed said: "I was glad I saw his corpse. It was so sudden that if I hadn't seen him dead I would keep expecting him to walk through the door." A corpse is also liminal—something that exists between two worlds, between spirit and body, between the dead and the living. The notion of the liminal comes from anthropology, but is also in the realm of art. Again, liminal things are kinds of doorways between worlds. Dusk is liminal—between day and night. A drag queen, a clown, a priest—these are all liminal people, between realms. The edge of a forest, a tide line, a cave going into the earth are all liminal places. If the idea of a corpse is too frightening for you to use—don't. But somewhere in your elegy, and in your other poems as well, try to explore the idea of the liminal.

I Know Who You Are

In the year—or two—after Robert died I wrote almost exclusively about his death. Death is one of the huge traditional realms of the poetry. It is the poet's bardic obligation to remember dead people, mourn them, praise them, relate their stories. The epic poet may do this for a tribe or nation; the lyric poet does it for herself, but also for others. After poetry readings of elegies people often come up to the poet in tears—the loss may not be identical, but one person's experience touches another's, and everyone has had loss.

In the poems I wrote about Robert, most did not follow a strict elegy form but all used elements of it. In one called "Handwriting," written about a year after he died, I began with the trope of nature mourning:

> I see rain fall on the end of summer
> Yellow chamisa and the orange leaves

Of my neighbor Grace's apricot tree
I see rain smear color like memory,
Color draining out of the world
Like New York City rainbow oilslick
Vanishing down the sewer grate.

The poem then moves into a combination of praise and remembrance:

Your handwriting is still everywhere in my house
You had beautiful handwriting, clear and bold,
And it has outlasted you.
I keep the bits and pieces
I couldn't bear to throw away,
Your calendar where the last thing written
Is "surgery"
And then the rest is blank.

Then an attempt at acceptance, mixed in with some anger:

The mail arrives for me, for my child,
For you, for the couple who lived here
For Angel who doesn't live here,
Mail arrives for the dead and living.
I should take your name off the gas bill,
I should take your name off the electric bill.

I read your notebooks without fear of revelation.
After all, years ago,
You burned those love letters from Miss X
In a tin can in the front yard of the old apartment.
I don't see your ghost on the corner
The way your friends and sisters can
To be honest, I don't want you around
You're dead, I'm not, we have to break up
As surely as if you'd run off to Cleveland with Miss X.

At this point, for me, the poem begins to resolve in a more positive manner, in part because it looks to a world beyond grief:

> I believe I will be happy.
> I am the only widow in my family
> But I am not the most unhappy person.
> I believe I will paint the bedroom pink
> I will go to Hawaii, and to Trinidad, Colorado
> I will buy red velvet to wear all winter.
> Since you died I have danced at a wedding,
> Been on three boats, seen falling stars
> And been given a free papaya at the market.
> I believe I will live to be old without you.

It is towards the end of the poem that a "corpse" appears. In a way, the handwriting is a kind of corpse, as is the ghost, but a truer one appears terrifyingly in the bath:

> I see your handwriting
> On the words of the Buddhist gatha
> On the note saying: Mir,
> Let's Have A Date.
> I see your coat in the closet
> I see your eyelashes on your daughter
> Your smile in her smile
> I see her sob, and hit the pillow,
> Wailing for you.
> I'm glad I don't see you as a ghost,
> Thank you for not coming back.
> The last time I saw you in a dream
> You were lying in the bathtub
> With your abdomen patched in black rubber.
> You said: "tomorrow I'll be dead."
> I'd like to see you well in a dream.
> I see rain falling over New Mexico.
> I say: good-bye, I'll see you later.

And the poem does end with a feeling of reconciliation.

I've long admired the poetry of Judyth Hill, who was born in Manhattan but now lives in the mountainous country behind Las Vegas, New Mexico. Her poem "Grapes from the Fishman" is an elegy for her mother. In it, true to life, the thought of death obtrudes unexpectedly, and is also connected to an anniversary of the loss:

> No one has asked me about her for so long.
> When the Neumans walked in my bakery
> I said My mother bought fish from you when I was growing up.
> I told him my maiden name
> and he said, Of course you're Suzanne's daughter.
> How is your mother?
> October is her 6 year Yahrzeit I say.
> It's hard he says, tears in his eyes and his wife hugs me.
> Later, they return with green grapes.

In the middle section of the poem, Hill remembers her mother, both good and bad—how she would enjoy being a grandmother but also nag the poet. At the end of the poem, Hill moves out traditionally into nature and to an integration of grief:

> And the tears for that moment,
> salty, burning, like the fiery tips of poplars,
> memories that flame, that catch and spread,
> the sting of autumn, aspens on the cusp of winter,
> and sweet too,
> grapes from the fishman, her name in conversation.

All people experience loss. If you are a poet, you will eventually be required to give a voice to the universal emotions of grief. The conventions of the elegy are helpful

markers on the path, but you can always use your own creativity to invent the forms you need. And the elegy ultimately offers condolence, and turns us towards life.

CHAPTER 12: THE LOVE POEM

Let Me Count the Ways

The love poem is like the elegy in that it comes out of a specific situation. Rather than being defined by formal constraints of rhyme and meter it is characterized by what happens in the poem and what the poem is about. Love is one of the basic themes of the lyric poem because sexual and romantic love are among the most intense *individual* experiences most of us will ever have. Love is not about battles and sieges, the history of a tribe, the protest of an injustice. It is not communal but is essentially private. It is about only two people—me and you.

When I went to look up "love" in my books of poetic forms, I surprisingly found nothing at all. However, this hasn't kept the majority of poetry—not to mention Top 40 Hits—from being about love. The love poem has no set formal constraints, although traditionally it was often written in sonnets. From William Shakespeare to Elizabeth Barrett Browning, an outpouring of romance has found its container in sonnet sequences. The conventions of the love poem, from the classical era through the Romantics, are based on a catalog of the beloved's virtues. This was sometimes taken to ridiculous extremes, where every square inch of the beloved was compared to some force of nature, praised, and scrutinized. Shakespeare even parodied this in one of his sonnets. But you can still use this technique for good effect. (This is essentially a List Poem.) To start off writing a contemporary love poem you might make a list of everything—*everything*—you love about your sweetie. Add a few humorous and eccentric details. Add a few things you hate. Then return to love.

Other elements of a love poem can include the trope of hyperbole—exaggerating the loved one's good traits or the lover's emotion. The love poem is also a fine place to practice the erotic poem: a short poem about desire and sex. For the erotic poem to work it doesn't have to be clinical, but it should be specific—these aren't general feelings, but yours. One of the most ancient poems in the world is an Egyptian lyric poem about love in which the lovers have beer for breakfast—which apparently was a staple of the meal at that time. This tiny lyric survived in part because of its specificity. In the European tradition, an erotically tinged love poem was sometimes written as an aubade, or dawn song—the reasoning being that the lovers were parting after a night of passion. In the classical Chinese tradition, there are poems of waiting for the lover, and perhaps even getting rained on as the hours of the night drag on. Anticipation, and memory, are both part of eroticism.

A bittersweet example of the contemporary love poem is Renée Gregorio's "Silent Dialogue." My favorite part picks up in the middle of the poem, where the writer admits to her slightly predatory nature as a lover:

> Some days I think want to get married.
> It's a matter of linguistics; I want to say husband.
> By the Rio Chiquito, Catanya told me lobsters mate for life.
> I thought of how many halves of couples I'd eaten.
>
> I'm sorry; I was hungry. When we woke this morning,
> we spoke without words of the wide, green field in the distance.
> It was before the alarm went off, after the shrill of coyote.
> Quick lightning split Pedernal.

Notice too that the poem quickly moves into the pastoral, an association of the lovers with nature. Like the elegy, the love poem draws parallels between the natural and the

human world. In Gregorio's poem, desire is implicitly compared to the flash of lightning on the mountain. Leo Romero's love poem "Red Dress" is in an extremely traditional vein. It begins with a bird, often an icon of love in Classical and European poetry, singing to the poet about his beloved, and comparing her heart to a garden. The poem then moves to the beloved's red dress, which represents passion, drying mundanely on a clothesline, but metaphorically "fluttering in the wind/like a God-bird." The poem continues with a scene that might be out of back country *Romeo and Juliet*:

> That same red dress
> I saw you wear
> at your cousin's wedding dance
> when you danced
> like a ball of fire
> My hands burned
> when we danced together
> I swear—they burned

In the final stanza, the poet again uses traditional comparisons of the beloved to the sun, but then surprises us by twisting up the images in a new way:

> A little bird has come
> to sing to me
> about your heart
> bright as any sun
> which you show
> so casually
> that all mistake it
> for a dress.

Wait a Minute, Mr. Postman

Another good way to write a love poem is to use the epistle or letter form. The epistle is one of the most ancient literary forms there is, because the letter is a natural form of communication. It presupposes an "I" who is writing and a "you" who is reading, and exemplifies not only the lover/beloved relationship but the writer/reader one. Early novels in English, such as Richardson's *Clarissa*, were written as a series of letters, and the form lives on today in such virtuosa epistolary novels as Alice Walker's *The Color Purple*.To combine the love poem and the epistle, start by writing a letter to your sweetie. The only conventions here are to start with "Dear___" and to make sure you sign your name. Write spontaneously for ten or fifteen minutes, then come back and edit the letter poem. Ask yourself: have I said everything I wanted to say? If not, add it in. Take out anything that seems extraneous. Type the letter up into a neat prose block and your poem is done.

The letter poem is essentially a prose poem. This seeming contradiction does push the boundaries of the poetic form, but the prose poem is legitimate, with literary antecedents. Charles Baudelaire wrote prose poems in French, and influenced other writers with his dreamy mix of images from nature and the imagination. How does the prose poem differ from other very short prose works such as the short short story? The key is that in the prose poem the work is fueled, as in all poetry, by association. The prose poem moves from image to image in a metaphorical fashion and uses leaps of imagery from surrealism. Its mood is that of a dream. A short short story, although tiny, has all the elements of fiction: plot, character, and setting. Essentially it tells a story while the prose poem evokes a mood. If these distinctions seem hazy, they are. If you want to experiment further with

the prose poem, limit the form at first to about a hundred words. If you are stuck working on a poem, try putting it into prose and notice the effects. You may keep it as a prose paragraph or put it back into line breaks. A prose poem can be very satisfying to write and to read—so don't be intimidated by the looseness or "prosiness" of the form.

Be Concrete

Another form related to the love poem is the concrete poem. A concrete poem is one in which the graphic elements—how the poem looks on the page—dominate. There is a famous concrete poem in which the word F-O-R-S-Y-T-H-Y-I-A is used over and over to create an image of a flower basket with sprays of forsythia, of course, blossoming out of it. You have probably seen posters of the painting of the word LOVE with the O tipsily tilted. This image has been replicated so many times that it is almost a cliche of itself. However, if you look at it freshly, you can regard it as a one-word concrete poem.

Writing concrete poems is not new. Ancient calligraphers sometimes formed whole texts into images. An example is the Hebrew calligrapher who wrote the entire "Book of Esther" in the shape of a bear. The metaphysical poet George Herbert wrote the most famous example in English, a poem called "Easter Wings," in the shape of a pair of wings. Concrete poetry has an element of collage. One of the ways to get started on concrete poetry is to use a notebook with blank pages, different from your usual writing one. Assemble some materials—magazines to cut up, colored pens or pencils, glue. Probably just the sight of these materials will take you back to childhood and a playful space. Give yourself ten or fifteen minutes to cut, paste, write, and see what develops. If you want to integrate the concrete poem and

the love poem use some valentines, hearts, red envelopes, stickers.

Collage and the concrete poem are a great way to overcome the feeling of being blocked. After my first husband died and I had trouble writing, I filled a blank notebook with collages. The collages were all the same—I ripped black paper into shapes and pasted it in. Interestingly, this seemingly unproductive activity was very therapeutic and gave me the feeling that I was doing something that resembled writing.

Over the years, I have seen students create huge poems on bed sheets and tiny ones on river stones. The widespread use of personal computers makes the concrete poem even more accessible—you can experiment with typeface size, style, font, and even color. There is a primitive, basic, impulse to put our words and images out into the world. From cave paintings to tags on subway cars, there is a desire to "write" on the world. Santa Clara potter and poet Nora Noranjo-Morse once told me that she often wrote her poetry directly onto the adobe mud walls of her studio. The concrete poem means just that—a way of making the poem physical in the world.

Going to the Chapel of Love

As it says in the children's rhyme: first comes love, then comes marriage. Marriage of course is more conventional than love—which may be illicit, forbidden, and unconsummated and whose passion is generally antisocial. This may be the reason that marriage, unlike love, has its own poetic form, the epithalamion. If you are ever asked to write a poem to read aloud at a wedding, you will be writing an epithalamion. And don't be surprised if this happens. Although generally poets—and poetry—are not highly prized in our

society, occasions like weddings, births, and funerals call up an ancient need for poetry. I have often had the experience of friends and family members suddenly noticing I am a poet when they start to plan their weddings, and I am asked to read, or write, a poem for the occasion. The epithalamion is more public than the love poem. Its conventions come from the Greek, and you might want to use some of them when you write a wedding poem. First, you can instruct the world to welcome the bridal pair. Sappho writes: "raise high the roof beams, carpenters," because the groom is coming. Then, as in the love poem, you can catalog the virtues of both bride and groom. In the opposite of an elegy, nature can rejoice, with flowers blooming, birds calling. And you probably want to conclude with a blessing on the bridal pair. It may feel stilted to you to have to write a poem on demand; such poems are called "occasional" poems for the very reason that they are written for a specific event. But don't be inhibited; the occasional poem is an ancient form, celebrating everything from military victories to birthdays.

When writing an occasional poem, you can't depend purely on inspiration. I often add a form—an accrostic works well for a birthday poem or valentine, and I wrote an epithalamion in pantoum form for one of my sister's weddings. And there is no need to be too serious unless you are writing for a president's inauguration! In an epithalamion, for example, you might put in specifics of the day—describe the park the wedding is in, or even comment humorously on the details of how the couple met. If you are asked to write an occasional poem, you have been honored as a poet; and by doing it you follow along ancient traditions of poetry.

A Blessing and a Curse

Poetry, at heart, like all language, is powerful in a magical way. As school children we may chant: "Sticks and stones may break my bones but words will never hurt me," but of course this isn't remotely true. Words can hurt—and help— us. During the early stages of the Iraq-Iran war, both sides hired Bedouin poets to sing on the radio and curse the enemy. When I read about this I wasn't appalled or even surprised—I was just plain jealous. I wished someone would pay me to do something of national importance on the radio! As poets, we need to wake up to the power of words. I don't suggest you start writing voodoo poems to all your old bad boyfriends or an occasional curse to the landlady who never makes repairs, because in general I feel one should be wary of the negative. However, the power of the curse does underlay some poetry. Look at Bob Dylan's song "Masters of War," which essentially aims a dark spell at warmongers.

A blessing, of course, is wishing for positive things in words. It is close to a prayer, which invokes, or asks for something, from divine sources. What's wonderful about blessings is that they are immediate and have no ambiguity. You may pray for a person to recover from an illness and not know what the outcome will be, but a blessing is complete in the moment. I am particularly fond of the traditional Hebrew blessings that bless not only food, drink, and holiday candles but also more unusual events, such as first blossoms, the sight of something extraordinary in nature, meeting a spiritual teacher, or even meeting a great secular ruler.

Ceremony

You can have a lot of fun writing a ritual or ceremonial poem, which essentially combines blessings with the form of a list

poem. First, find yourself a subject. It doesn't have to be elevated, like "How to Bring World Peace," although that might work nicely. It can be something silly or mundane, like "How to Keep a Ten-Year-Old Toyota Running Smoothly." Then decide on a number of steps, preferably ten to twenty. Start with one, and let the narrative quality of the list prevail. Combine some realistic with some magical points. For example, in your Toyota poem step one might be to change the oil frequently, but step seven might be to hang a pair of pink fuzzy dice from the rearview mirror or to wash the car in river water or to speak to it in a soothing tone of voice. You can also write a ceremonial list poem "To Get Rid of Bad Love," "To Draw New Love," "To Name a Baby—or a Cat," "To Get Money," "To Get Laid Off," or whatever else is currently on your mind.

Allow some of the magical quality of poetry to enter your work. This isn't rational or formal, but reckless and wild. Yet from the love poem to the epithalamion to blessings and curses, words have the power to act on our hearts and therefore on our lives. It seems no coincidence that all these forms use some kind of list. The list is a container for energy and proceeds regularly, but its pseudo-scientific quality—or magical quality—convinces us it can make something happen, both on the page and in the imagination.

CHAPTER 13: FREE VERSE

Vers Libre

I've always enjoyed the term "free verse" because it has the ring of a slogan, as if poetry were in prison and needed to be sprung through demonstrations and street riots. The formalist Robert Frost said that writing free verse was like playing tennis with the net down. He meant this as a criticism, but it is a rather charming image out of a Woody Allen spoof on a Bergman movie. And playing tennis without a net can be an enterprise all its own. Since most of the poetry in the United States today is written in free verse—and since in all probability this is the form you will use the most yourself—it is worth examining this supposedly rule-less form.

Free verse comes from the French term vers libre. The French form is essentially syllabic, since French poetry does not use stressed syllables. This syllabic, unaccented, unrhymed form was picked up by Ezra Pound, Amy Lowell, H.D., and the other Imagists almost a century ago and used to create tight but informal lyric poetry. This form of free verse also influenced Charles Olson and William Carlos Williams to introduce their theory of syllabics (see Chapter 3) into the mainstream of American poetry.

Essentially, free verse as it is written today is not completely free but is "freer" verse. Its hallmarks are that it has no consistent rhyme or metrical pattern, although it may have a variable music and use slant or partial rhymes. It is often syllabic, if not strictly so, with lines of comparable length. Stylistically, it may use contemporary fashions in poetry—direct and vernacular speech, an element of confession, a

plain veneer. Or it may derive more from Walt Whitman and Allen Ginsberg's "barbaric yawp," using long wild lines to create a mystical incantatory quality. I once saw a beautifully renovated loft in New York's lower Bowery area. It had some remnants of its industrial past, acres of white walls and polished floors, and one perfect apricot-colored classical column for decoration. Good free verse is a little like that loft—the classical techniques are still there, but they are not the obvious scaffolding.

Cut-Ups

Writing free verse should be fun. Actually, all the writing of poetry should be fun, although we lose sight of that when we aim for seriousness or perfection. Many of the traditional forms—from pantoum to sestina— introduce that element of play by cutting up lines and words and rearranging them with a somewhat random quality. Free verse doesn't usually invoke the random—and the sense of play and creativity it brings—so the following exercises are designed for just that. Here are a variety of techniques to slip you free from your cognitive and controlling mind and into the pleasures of being out of control.

1. Cut-Ups. Get some magazines and newspapers and cut up words that appeal to you. Start arranging them, and then glue them to a piece of paper. To introduce more elements, use your pack of poetry word cards. You can also cut up an old poem of yours, move the words around, add cut-out words. You can use the dictionary, too, by opening it at random. Or you may be able to program your computer to generate words at random. The French surrealists used to do this by dropping handfuls of words on the floor. See if you can't shake your poetry up—literally and figuratively— this way.

2. Tabloids. As I am a well-educated and literate woman, I never read the tabloids while waiting on the check-out line at the grocery store. Well, hardly ever. And trust me, if I do read them, it is for the sake of my poetry. When my daughter was tiny I saw a headline in one: BABY FOUND INSIDE WATERMELON. That was just too tempting. I bought this sleazy rag, and wrote a poem with the same title as the headline. I recently wrote a poem about the allegedly 2,800 pairs of shoes abandoned on the New York subway. Why? How? Did all those people walk away barefoot? That was what my poem attempted to address.

Tabloid poetry bears a relationship to Found Poetry, which is just the taking of an existent prose text and breaking it into poetic lines. This is great practice, and sometimes bears good results. Find a luscious piece of prose—maybe a translation from one of the Latin American magical realists— and strip it down into poetic lines. At worst, you'll learn something about line breaks, at best, have a basis for your own poem. You can also create an ironic or political poem using this technique on newspaper reports.

3. Translations from an unknown language. If you suspend your disbelief for a bit, this exercise can be startlingly fruitful. First, find yourself some poems in their original language, along with translations. *The original language must be one that you cannot read at all.* Now, take the original, whether Russian, Chinese, or French, and "translate it." Of course you are really free-associating, or inventing as you go, but in many cases some flavor of the original may mysteriously enter your creation. When you are done, compare yours to a real translation, look, laugh, and see if you don't have a germ of a poem.

Meet the Poetry Police

Probably each poet, and certainly each teacher of poetry, develops certain prejudices about what poetry should *not* do. I first encountered this with a freshman year poetry teacher I had in college. He hated—hated—poems that were composed of long skinny lines. Of course at that time my lines were composed of one or two words—I didn't yet know how to count syllables—and my work was anathema to him. Although I didn't lean much else from this overly critical teacher, I did lengthen my lines, which was invaluable as it added music and breath to the poetry.

My own prejudices now include very short lines or lines of one word, although I will on occasion use them. Also, beware of scattering the poem about on the page, using indentations and white space randomly. Work from some pattern, at least, which makes sense, not just a vague belief that unstandardized margins "look good" or "look like poetry." Other tics to avoid are overly archaic—inappropriately outdated—language. This often comes about from a need to rhyme, using words like "thus" or "lad" just for the sound. In the same context, be wary of inversions where you put a word at the end of the line just so you can rhyme it.

The thing I dislike most in student poetry is writing about writing. It always sounds pretentious to me, and I suspect most of these aspiring poets know more about other things—gardening, children, travel, love, carburetors, suffering, sky diving, chiles, insomnia—than about the writing of poetry. Write what you know is a dull truism, but if you observe what you know in its specifics—whether it is how to panhandle or a sunset off your back porch—your poetry will benefit. Poets always argue with me about this—there have been some good poems written about writing, and for some

reason the subject is tempting. But I try to avoid it. If you are a poet who loves to write about poetry, trying giving yourself a six-month ban on the subject, and see what else you can come up with.

Revision

The literal meaning of revision is "to see again," not to re-write, over edit, or beat into the ground. When I first started writing poems, I used to do between thirty and forty drafts. Now I do about ten percent of that. After a stay at the MacDowell Colony, I became influenced by the way I saw print makers work in color series. I became more inclined to write in bulk, and then throw things out if they didn't work, rather than to revise them endlessly. However, revision remains an important part of many poet's process. Arthur Sze writes numerous drafts of each poem on his electric typewriter. Without a computer, each draft remains a physical entity. This is an almost sculptural way of working.

A good revision asks, and answers, several questions. First of all, where does the poem begin? Start there, even if it means cutting (remember Robert Fitzgerald's pencil). Gently go over each line—is the word choice precise? Is the sound fluid? If a bit seems awkward or unmelodic, come back and count the syllables, check where the line should break. Did you leave anything out? Did you say what you meant to say? Did the poem have a chance to finish, to run to its natural end, or was it somehow cut off prematurely? Do you want to put it into a stricter form, or into looser lines? Fiddle around, putter on the page. Take a gentle and kindly attitude towards the poem. William Butler Yeats said that poems are never finished—they are abandoned. No poem—no thing, actually—is ever perfect. However, it may be done. Eventually, give up the revision process, and accept the poem. Then write another one. And another.

The Poetry Field Trip

Poetry is about the intersection of the world of experience and the world of language. It is not possible to have large experiences—such as love or death—on cue just to write about them, but it is possible to have smaller ones. In Asia, particularly in Japan, it was traditional for poets to go out actively seeking standard poetic material to write about, such as cherry blossoms, changing foliage, the first snow, moonlight. The English Romantic poets liked to situate themselves well, romantically, in ruined churches and along desolate coastlines and moors to seek poetic inspiration.

You can do this yourself in the form of the poetry field trip. All you need is a notebook and a sense of what interests you as a poet. There is nothing wrong with following in traditional footsteps. Go out into nature, and observe it seasonally. Try and find some ruins, which isn't as difficult as it sounds. When I lived in San Francisco I found the ruined Sutro Baths at the beach and the Palace of Fine Arts, which was designed to crumble in places. In New Mexico ruins are easy to come by—those left by the Anasazi, the historical pueblos, and even by the crumbling of more recent adobe buildings. Seasonal change and ruins have one thing in common—the passage of time. Much of poetry is about change, and how that adds poignancy to life. Look for a field trip that will bring out this poetic idea.

You can of course do anything else you like—visit an art show, a cafe, a button wholesaler, an ethnic neighborhood, a bakery, a steel mill, your old grade school, or anything else which catches your poetic fancy. The field trip is part inspiration and part research for a poem. It will work equally well if you have the germ of an idea before you go, or just plunge into the experience. Many poets are inspired by

travel, because the new and unaccustomed reawakens the senses. You don't have to go to Italy or Tahiti, however. You can go to a big city flower market early in the morning, a Civil War battle site, a tiny pioneer graveyard, a Pueblo dance, a bead store, an extinct volcano, a used car lot—anywhere at all. Just make sure you give yourself ample time alone, and write about it.

Free verse can be fertilized by many techniques, from syllabics to classical forms of inspiration. It is our most common métier, our contemporary idiom. But like all poetry, it has its traditions and parameters—and the more you study, practice, and absorb it, the more it will yield to you.

CHAPTER 14: THE LIFE OF A POET

There is only one thing you must do to consider yourself a poet—write poetry, and continue to write. No matter how much you publish, or what honors you win, you will never "accomplish" being a poet the way you might accomplish becoming a physician or master carpenter. That is because poetry essentially is a process, and although it creates finished products it does not create finished people. Also, anyone can, and should, write poetry, from school children to prisoners. Poetry is essentially unownable—it belongs to the human race—and it is the role of the professional poet to remind us of that again and again.

Still, even a poet has to live in the non-poetic world most of the time. For many writers, a central conflict, real or imagined, is between the role of solitary writing and family life. It is simple enough to tell you to close the study door or take your notebook out to a local cafe—but on the non-practical level the conflict is still there. I have a mantra that has helped me with this; I repeat to myself, "Your family is not your audience, or your enemy." It's natural to want the love and approval of our nearest and dearest for our art, but it is not necessarily forthcoming.

I have been married twice, and my two husbands could not be more different as poetry audiences. My first husband, Robert, loved poetry, poets, art, performance, and adored that I was a poet. He promoted my work, critiqued it, edited all my books. When he died, I knew I had lost not only a friend and spouse, but my greatest fan. My second husband, Rich, had never even been to a poetry reading until he became involved with me. He'd watch me perform with

enthusiasm and embarrassment mixed on his face. Unlike Robert, though, he is a man with a conventional job who helps support our household. He is a champion grocery shopper, cook, and dish washer. Because of his care and nurturing of the details of daily life, I have written more poems—and books—living with him than ever before. So be careful of thinking that support comes only in one package.

Your family is also not your enemy. They interrupt you, demand things from lost sneakers to existential explanations, and will not help you create the time to write. But that is simply because they—children, spouses, pets, parents— are treating you in the usual sociable way. You can train them to leave you alone, but be sure to appreciate them more than you resent them. The truth is, a person is more important than any work of art, and without the vitality of life there would be no poetry. In order to really enjoy your family, you must look for a community beyond it.

It is important, although not completely necessary, to find some like-minded writers with whom you can share your concerns. For many contemporary poets, a natural community is found in college writing classes, or in graduate school. For adults who aren't in school, consider taking a local class anyway, if just to find other writers. You can also set up your own peer workshop of poets. Often, posting a notice at a bookstore will do the trick—or place a small ad in the newspaper. Consider what you want—a critique group that shares work, a support group that shares ideas—and see if you can't create it.

Some poets and aspiring poets are also starting to find community on the internet, through on-line poetry magazines,

resource listings, and users' groups. There are also an increasing number of distance learning classes in creative writing offered by universities.

Although poets may tend to be somewhat solitary by nature, the community that works best is the one you make for yourself. Go to as many poetry readings as you can—by both well known and local poets. You may not like everything you hear, but you'll keep training your poetry ears. Sending work out for publication is too large a topic to discuss completely here. However, it can be an important final step for many poets—the act of sending work out into the world. It is most helpful to think of it that way, as a process of completion rather than as a process of looking for approval and being devastated by rejection. Many poets do find a community by mail in working with little magazines and magazine editors (see Appendix for some publishing resources). An easy way to find at least some literary magazines that publish poetry is to browse a good newsstand/cafe, look in a bookstore with a large poetry section, or check the periodicals at a public or university library. If you tend to be sociable and energetic, you can start your own small poetry magazine—alone, or with some friends. If you have a poetry group, or even a single poet friend, you can set up your own readings at the public library, a cafe, or bookstores. These experiences of going out into the world may nurture your sense of belonging as a poet. Above all—read. Read dead poets, and living, ancient and new. Allow their voices to sustain you as you write, and to expand your notions of the boundaries of a poem.

A poet must live in the world, like everyone else. Dualistic thinking is one of the greatest enemies of creativity—putting up barriers and creating hierarchies between solitude and

family, writing and paying work, poetry and the mundane tasks of living. Your spiritual practice as a poet is to think, live, breathe, and write metaphor. Everything is connected. And it is up to you to make and remake those connections freshly every time you sit down to write.

APPENDIX

The poems used as examples in this book are all the work of people I know—living poets of New Mexico. I decided to do this for several reasons. First of all, I love their work, and I also understand it and something of how it was made. Several of the poets included here were my students—all have been my teachers. Some are close friends, others more of acquaintances, but together we have eaten meals, given poetry readings, and attended weddings, baby showers, funerals, and all the parties of an informal community. There are already more than enough books on the market that draw their poetic models from the standard academically admired poets. I wanted my models to be from working poets I knew. I suspect that if asked many of the poets included here would define themselves as Romantics, working in the euphoric emotional tradition, and yet their poems were chosen as examples of traditional poetic form. There need be no contradiction between the two. To find more of the work of these poets :

John Brandi, *Weeding the Cosmos* (La Alameda Press, 1994) and *No Other Business Here: A Haiku Correspondence* with Steve Sanfield (La Alameda Press, 1999)

Alvaro Cardona-Hine, *Thirteen Tangos for Stravinsky* (Sherman Asher Publishing, 1999), *A History of Light* (Sherman Asher Publishing, 1997), *When I Was a Father* (New Rivers Press, 1982), and *four poems about sparrows* (Eye Light Press, 1994)

Renée Gregorio, *The Skins of Possible Lives* (Blinking Yellow Books, 1996) and *The Storm That Tames Us* (La Alameda Press, 1999)

Judyth Hill, A *Presence of Angels* (Sherman Asher Publishing, 1995), *Men Need Space* (Sherman Asher Publishing, 1996), and *The Dharma of Baking* (Celestial Arts, 2000)

Tony Hoagland, *Donkey Gospel* (Graywolf Press, 1997) and *Sweet Ruin* (The University of Wisconsin Press, 1992)

Elizabeth Searle Lamb, *Across the Windharp: Collected and New Haiku* (La Alameda Press, 1999)

Joan Logghe, *Twenty Years in Bed With the Same Man* (La Alameda Press, 1995), *Sofía: Poems* (La Alameda Press, 1999), and *Blessed Resistance* (Mariposa, 1999)

E.A. (Tony) Mares, *The Unicorn Poem & Flowers and Songs of Sorrow* (West End Press, 1992)

Mary McGinnis, *Listening for Cactus* (Sherman Asher Publishing, 1996)

Carol Moldaw, *Taken From the River* (Alef Press, 1993) and *Chalkmarks on Stone* (La Alameda Press, 1998)

Leo Romero, *Agua Negra* (Ahsahta Press, 1981) and *Going Home Away Indian* (Ahsahta Press, 1990)

Miriam Sagan, *The Art of Love* (La Alameda Press, 1994) and *The Widow's Coat* (Ahsahta Press, 1999)

Arthur Sze, *The Redshifting Web: Poems 1970-1998* (Copper Canyon Press, 1998)

Anne Valley-Fox, *Sending The Body Out* (Zephyr Press, 1986)

Books To Serve As Guides

The Book of Forms: A Handbook of Poetics by Lewis Turco (E.P. Dutton, 1968). This slim paperback may be out of print, but can easily be found in used book stores and library sales. It gives a handy overview of every imaginable form in a succinct manner.

The Teachers & Writers Handbook of Poetic Forms, edited by Ron

Padgett (Teachers & Writers Collaborative, 5 Union Square West, New York, NY 10003, 1987). This book is your poetry bible! It clearly sets out the most useful poetic forms with grids and excellent examples. Use it as a textbook, working your way through it. As you become more adept, use it as a reference.

The New Princeton Handbook of Poetic Terms, edited by T.V.F. Brogan (Princeton University Press, 1994). An actual encyclopedia of poetic forms, ideas, and tropes. It is a great reference and source of inspiration. Look things up, skim, and use it to enrich your own poems.

New Mexico Poetry Renaissance, edited by Sharon Niederman and Miriam Sagan (Red Crane Books, 1994). The work of many of the poets discussed here is collected in this anthology, along with other fine work.

Haiku Handbook: How to Write, Share, and Teach Haiku by William J. Higginson with Penny Harter (Kodansha International, 1985). A concise and indespensible guide to the art of haiku. The season/word list alone is invaluable.

Publishing Resources

International Directory of Little Magazines and Small Presses (Dustbooks, PO Box 100, Paradise, CA 95969). Look up "poetry" in the index, or the place you live, as a starting point. The book is huge, and may seem daunting at first, but is the primary resource for publishing your work. Dustbooks also publishes *The Directory of Poetry Publishers*, which is more compact and may be the best place to start. Updated annually.

Poetry Market (Writer's Digest Books, 15077 Dana Ave., Cincinnati, Ohio 45207). Another useful listing of poetry markets. Updated for each annual edition.

Poets & Writers (72 Spring St. New York, NY 10012). $19.95 yearly subscription. This bi-monthly magazine is an excellent way to find out what is happening on the poetry scene. Take a particular look at the classifieds, where magazines and presses put out their calls for submissions.

Internet Resources

Although there is a great deal of poetry out on the World Wide Web it is often uneven in quality and sites come and go rapidly. Web sites of established print magazines and writers' organizations are good places to begin. Long time small press editors are also creating content-filled sites.

American Academy of Poetry

www.poets.org

Poetry Magazine

www.poetrymagazine.com

Poets & Writers

www.pw.org

Writer's Guild of America

www.wga.org

The work of many of the poets included in this book can be found at **The Santa Fe Poetry Broadside: Poets of the Region and Beyond**

www.rt66.com/~sfpoetry/

Also see **Sherman Asher Publishing**'s site at www.shermanasher.com

Index

About the Author

Miriam Sagan was born in Manhattan and raised in New Jersey. She holds a BA from Harvard and MA in Creative Writing from Boston University. She is an acclaimed writing teacher and author of more than a dozen books of poetry, fiction, and non-fiction. She has held residency grants at Yaddo and MacDowell and is the recipient of a grant from the Barbara Deming Foundation and a Border Regional Library Association Award. Her work has appeared nationally in over 200 magazines. She has taught writing at Santa Fe Community College, Taos Institute of the Arts, Aspen Writers Conference, and in workshops across the United States. She now lives in New Mexico with her husband Richard Feldman and her daughter.

About the Cover Artist

Roshan Houshmand is an Iranian-American artist who received her BA from Bennington College in Vermont and her MA and MFA fom Rosary Graduate School of Art in Florence, Italy. She currently lives in Pennsylvania.

About the Press

Sherman Asher Publishing, an independent press established in 1994, is dedicated to changing the world one book at a time. We are committed to the power of truth and the craft of language expressed by publishing fine poetry, memoir, books on writing, and other books we love. You can play a role. Bring the gift of poetry into your life and the lives of others. Attend readings, teach classes, work for literacy, support your local bookstore, and buy poetry.